MY LIFE
with the
SALMON

Diane Jacobson

© 2011 Diane Jacobson.

Library and Archives Canada Cataloguing in Publication

Jacobson, Diane, 1955-
My life with the salmon : in the valley of the Gwa'ni life cycle
/ by
Diane Jacobson.

ISBN 978-1-894778-88-6

1. Jacobson, Diane, 1955---Childhood and youth. 2. Pacific salmon.
3. Pacific salmon--Conservation--British Columbia. 4. Kwakiutl
Indians--British Columbia--Alert Bay--Biography. I. Title.

E99.K9J32 2010 971.1'2004979530092 C2010-901347-6

Printed in Canada

Printed on Ancient Forest Friendly 100% post consumer fibre paper.

www.theytus.com
In Canada:
Theytus Books, Green Mountain Rd.,
Lot 345, RR#2, Site 50, Comp. 8
Penticton, BC, V2A 6J7, Tel: 250-493-7181
In the USA:
Theytus Books, P.O. Box 2890, Oroville, Washington, 98844

 Patrimoine Canadian
canadien Heritage

 Canada Council Conseil des Arts
for the Arts du Canada

BRITISH COLUMBIA
ARTS COUNCIL

Theytus Books acknowledges the support of the following:
We acknowledge the financial support of the Government of
Canada through the Canada Book Fund for our publishing
activities. We acknowledge the support of the Canada Council
for the Arts which last year invested $20.1 million in writing
and publishing throughout Canada. Nous remercions de son
soutien le Conseil des Arts du Canada, qui a investi 20,1 millions
de dollars l'an dernier dans les lettres et l'édition à travers le
Canada. We acknowledge the support of the Province of British
Columbia through the British Columbia Arts Council.

My Life with the Salmon

Diane Jacobson

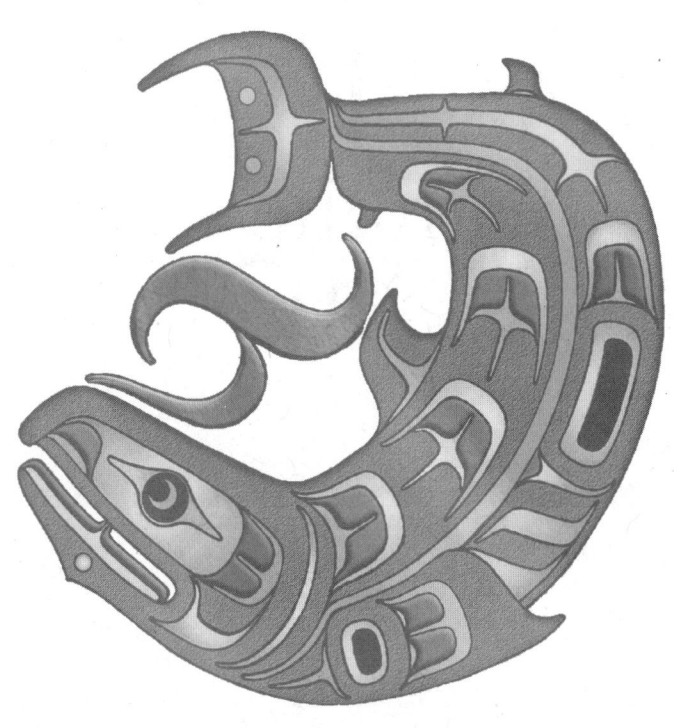

Table of Contents

1. A 'Namgis Origin Story — 1
2. My Story Starts — 5
3. Educate and be Educated — 7
4. First Working Days — 11
5. Water Experience — 15
6. Doing What Comes Naturally — 19
7. NERP Twerps — 23
8. A Day on the Beach - August — 27
9. The Day Officially Begins — 29
10. Second Day in the Valley — 39
11. Rainy Season — 41
12. Caught by the Baz — 45
13. A Hard Day Working with the Baz — 49
14. We all have a "Baz the Boss" Day — 53
15. New Experiences — 61
16. Shared Memories — 65
17. More Willow Creek Adventures — 69
18. Back to Willow — 71
19. October Enumeration Crew Work — 73
20. Education Dollars at Work — 81
21. A Day as "Fry Recapture and Reach Workers" — 83
22. Another Day as Lead Hand of the Whe-la-la-u Crew — 89
23. Lukwa Creek Rover Reaches — 99
24. Klaklakama Lakes Fishing Days — 105
25. Another Day Fishing — 111
26. A Day Working with Bert — 115
27. Davie River Fishing — 119
28. Fry Reconnaissance on Kamadzina — 125
29. Hatchery Work in the Nineties — 131
30. Chum Fishing and Transfer — 137
31. A Feel Good Day — 143
32. Ever-Changing River — 145
33. Thirty Years of Broodstock — 149
34. Another Decade and Another Dollar — 153
35. The Hatchery Crew as it Evolved — 157
36. Reflecting on my Years in the Nimpkish Valley — 161
37. Laxwe'gila - Canoe Journey — 167
38. Conclusion — 171

Chapter One
A 'Namgis Origin Story

The 'Namgis origin story tells of the killing of water monsters.

Ḵwaḵwaksanukw
Told by Agnes Alfred

Chief Hamalakawe' of the 'Namgis had two wives. One was named 'Maxwala'yugwa, who was the mother of Ḵwaḵwaksanukw. The other wife was named U'magasama'yi. Her son's name was Muxwsaga'wakwi, which means Tied-one.

The wives raised their children in two different villages. The two boys finally met while travelling in the 'Namgis (Nimpkish) Valley. Both young men obtained supernatural powers, which they used to hunt and kill enemies and water monsters.

They killed the Gilford warriors who had forced their mothers to flee for their lives. A petroglyph found in 'Namgis territory shows the enemies tied to stakes with eagle-down on their heads and birds pecking their eyes out.

Their mothers were pregnant at the time of the war between the 'Naṃgis and the Gilford people. The mothers of Ḵwaḵwaksanukw and his brother were taken by the Ḵwiḵwạsutinuxw. When one woman was giving birth at Gilford Island, those who took care of her were told, "If she gives birth to a boy, kill him, but if it is a girl, save her."

When the baby was born, those who took care of her were not present, so the mother took a piece of cedar bark and tied it to the end of her newborn son's penis. She pulled it round behind the baby, so that his testicles were pulled flat and the baby looked like a girl.

When her caretakers came, the mother said, "Wisa is a little girl." Each day, she would put her son into a basket and put him into the river, so that he might grow quickly. The baby would cry all the time, because he wanted to be put in the water.

When he grew up, he ran away.

Ḵwaḵwaksanukw followed the bear as it swam across the river at Asiwa'yi (an old village site halfway up the lower Nimpkish River). He did not know that his brother had also arrived there.

He ran after his brother, saying, "Don't touch what it is that I am always after." His brother said, "Show me what it is you do to that which you are always after."

The Nimpkish River used to be full of 'yagạm (water monsters). It was not thought good to travel on it.

So Ḵwaḵwaksanukw aimed his bow at the bear.

His bow had at the end of it a scale from a sisiyutł (two-headed sea serpent).

The bear turned to stone and sank in front of Asiwa'yi, where it can be seen in the water on the beach.

The old people used to say that if they wanted it to rain, they would go there and poke a pole at the rear end of the stone bear.

It was there that Ḵwaḵwaksanukw and his brother came together. They had not known of each other's existence until they met there. They stayed there for a short time, then travelled up the river.

They would push logs into the water, which the 'yagam would all rush. Ḵwaḵwaksanukw would aim his bow at them and they would turn into stone.

That is why all the 'yagam disappeared from the river, because of the treasure Ḵwaḵwaksanukw's mother found, while digging clams at U'dzo'la's (a fishing village at the lower end of Nimpkish Lake), the scale from a sisiyutł, which was put on the end of her son's bow.

Alfred Agnes (1978). Nimpkish River - Use and History. Gloria Cranmer Webster. U'mista Cultural Centre. P. 1-3, 3-A, 7-8

My Life With The Salmon

Chapter Two

My Story Starts

Today, I do all the treaty research for my band—now named the 'Namgis First Nation—and have been doing this for the past seven years. Some Elders who I greatly respect do not like the word "Nation." They feel we jumped on the treaty bandwagon by using words that are not part of what we are as a people. They feel the title 'Namgis is enough. I want to write this story to tell of my love for the Nimpkish Valley, and why I love it so much. I will try to stay away from politics.

I know that my inner feelings will come out as I tell this story and it will be reflected in the storyline. Everything I do today ties back to that one aquaculture diploma that I thought so little of, back when I received it. I never realized how much that one course would mean, nor all the jobs that would come about because of my diploma. That course eventually led to the job I have today.

In the early 1980s, I got my first hatchery work in the Nimpkish Valley working with the 'Namgis crew. Aquaculture taught me humility and great respect for my living Elders today, along with even greater respect for previous generations, those who passed on the oral history. My present position is in treaty research, this gives me insight into how our ancestors lived and how tough their lives were. It made my work as a young adult in the Nimpkish Valley seem so trivial compared to what I have now.

One of the first things I learned was that the word Nimpkish is a non-Native term for the Kwak'wala word 'Namgis, which loosely translates as the "First Ones." I find this so appropriate today because I truly believe this. I do not believe that we originated in another continent and crossed a land bridge to get here. That is an easy excuse for the government and others who do not want to admit they illegally took our land. It is an excuse to say we were not originally from here, so we have no right to ownership.

Among some key facts one should know is that 'Namgis leaders voluntarily stopped food fishing at the mouth of the river because of declining stocks in 1978 and even though it was part of our traditional fishing territory, we have not fished there with our families since that time. In 1958, the Department of Fisheries wrote that the Nimpkish fishery was second in value only to that of the Fraser River. The Nimpkish River sockeye alone totaled 130,000 the year before and it has been on the decline ever since.

Total salmon escapement has declined by ninety-five percent. There were only 10,000 sockeye in the year 2000. 'Namgis took it upon themselves to have Gwa'ni Hatchery start doing sockeye enhancement in 2001. The hatchery tries its best to bring sockeye and chum stocks back, but it is like trying to plug a dam with your thumb. The salmon numbers continue to dwindle.

The latest fish numbers from our Gwa'ni Hatchery show a low of 6,000 to a high of 21,000 salmon from the years 2000 to 2004. The chum salmon return dropped to less than one hundred fish in 2003 and this run may be virtually wiped out.

Chapter Three
Educate and be Educated

College is out! Everyone at home thinks I was doing so well at college. Guess what, I was young, and I was playing Native basketball and not attending classes. It is so hard to smile and lie to family, saying that all is well at school. But go figure, I went and lied once again, and told people that I needed a break from education.

I ended up abusing 'Namgis dollars that could have gone to someone who would have graduated and made a difference in our community. I know I should have felt guilty, but I was taught from an early age that I was a ward of the state. I knew that the money came from the Department of Indian Affairs and did not affect the Band dollars for everyday administrative duties. The Native mentality I was brought up with was that it was the government's responsibility to take care of me, and I saw it as my God-given right to be given this education money, to use or abuse as I saw fit. Some may see that as wrong and a mistake, but I still do not feel that I did anything wrong. One must remember, however, this is how I saw things at a younger time of my life.

When I took a break from college, I decided to stay home and signed on for an aquaculture course at North Island College in the old St. Michael's Residential School. Nobody questioned why I was

My Life With The Salmon

taking a break from college. Maybe they thought I was homesick. I was, but would never admit it. My cousin, Lavina, signed up for the same course, along with many of my other relatives.

I wondered at the time why my brother Joe's best friend, Bert Svanvik, had signed up for the program, because he had never seemed serious about anything. To my surprise, he eventually became my boss and role model.

The course was intense and involved a lot of biology. Even though I had grown up in a fishing community, I had to learn how to tell the difference between the five salmon species: chinook, chum, coho, pink and sockeye. A coho salmon looked like a sockeye to me. I did not know that the scales were different. I did not know that the rays on the tails were also of various sizes and amounts on all five salmon species.

When I was growing up, the boys told me what kind of fish we were canning or smoking to be preserved over the winter months. The instructors taught us all about the life cycles of salmon. Between the lectures, tests and hands-on teaching, we ended up going to various salmon hatcheries on Vancouver Island.

As part of the course, we had a small swimming pool placed in an old airplane hangar just past St. Michael's Residential School. We managed to have running water go through this pool, which supplied oxygen to salmon fry so we could raise them until we were able to release them into the ocean. This was when we learned to rear small salmon fry for the first time. It was a tedious job, with many hours spent doing initial feeding so that the fry would not die. Fry that do not learn to eat form large heads with small bodies; they are called "pinheads." These deformed fry are picked on by the stronger fish.

Since pinheads were smaller and unable to get the food, they always died. I saw a connection to us as Natives, and how we were also unable to be nourished. I am not saying we died because we were smaller in number compared to non-Natives but we were losing out on our main food source, which was the salmon.

I connected with the pinheads because I saw their plight. They were smaller, outnumbered and pushed around. I fought a few times with our instructors, Mike and Bill, about certain aspects of the course, because I disliked the repetition of the duties involved with the fry. To be honest, I now know that I felt inadequate because of my insecurity. I felt like one of those pinheads. The very first time that I babysat the fish, it was a small pool of coho that I did not care for at all.

After the coho fry were a certain size, they were transferred into the ocean. The class placed all the fry into three large net-pens right in front of the old residential school at our Native breakwater. Near the end of the course, three of the students were given the option to feed and raise the coho. Each student had one net pen they had to feed twice a day. Once the fish were large enough, they would be able to sell the fish at market for a personal profit.

My cousin, Deane, was one of the people chosen to raise and sell the coho. She went to Mike one day and said, "I don't know what is wrong with the fry but they have not been coming to the top to eat when I throw the feed in, for the past couple of days."

"That is strange," Mike said, "those fry should be coming to the top to feed as soon as they see you walking towards them."

"Well, the fry were eating good last week," Deane said.

"I sure hope it is not some fish disease but I will go and see later today." Mike went down to check and noticed that the pens seemed to have less fish in them.

He put on his diving suit and eased himself into the water. As he was swimming around the net pens, he noticed big holes in all three of the different pens. An otter or a seal had made holes in the pens and were feasting on the fry. A decision was made: the loss of fry was too great to even attempt to market and the three fry babysitters lost out on their potential revenue. The remaining fry were not used for sale, instead they were released into the wild and set free to do what salmon do naturally.

Four years later, those same coho tried to come and swim back into the old airplane hangar where they had been raised. There was no river access but the adult salmon recognized the smell of the water flowing down from the airplane hangar!

I figured out that our instructors were not just blowing smoke out of their butts (as my previous attitude had me believe) they had explained the salmon life cycle. The fry really were imprinted with the water that they had been raised in. It wasn't until I graduated from the course that I learned to talk the talk, and I did the full walk upon completion of the course. I did not go back to college to finish the Recreation Leadership course but felt very happy that I finished this aquaculture program.

Guilt ate at me because I had mocked Bert, who ended up finishing near the top of the class after the ten-month course was done. I had viewed Bert as my younger brother Joe's Red Power friend who would never amount to anything. When we started the course, he had hair down to his shoulders and was a physically fit, dark Native jock, always joking around.

Bert absorbed the information given to us and always had questions for Mike and Bill that made us open up our eyes about certain things. Boy, was I ever wrong with my first impression of Bert.

Even though I knew it had been wrong to accept the education dollars for the Recreation Leadership course that I never completed, I was very proud that I finished the aquaculture course. Sometimes it takes a while to find our right path.

I identified with the salmon I studied who had been imprinted with various river tastes and smells that compelled them to return to the same river after their ocean journey. I did not finish college, but I came back home, much like the salmon. I found my way to the aquaculture course. I did not know it at that time but this was just the first sign of my future life and why I would eventually fall in love with the Nimpkish Valley and come back over and over.

Chapter Four

First Working Days

Many of us were hired right away, on a pilot project started by the 'Namgis First Nation in 1977. The pilot project started because of the declining salmon stocks in the Nimpkish River system.

Everything started off as small baby steps for those in the aquaculture program. We were going to attempt to bring up the salmon stocks in the Nimpkish River, which used to feed all the 'Namgis people and many others on the northern end of Vancouver Island.

Our first small hatchery was over at the mouth of the Nimpkish River, just below the old village of Xwalkw. On most maps, it is called Cheslakees and can be found on National Topographic maps as Indian Reserve #3. It was located on a small stream running into the river. This was the source of our water supply that kept fresh oxygen going into the incubation troughs where we were holding the salmon eggs. Each night, one of us had to stay in a dilapidated trailer near the side stream to make sure the eggs were getting enough water for their oxygen supply.

The rest of the crew went back home to Alert Bay on aluminum punts (long aluminum boats) and speedboats at four-thirty and then came back the next morning at seven. Mike was hired on as the biologist consultant and Basil, who was our boss, realized there

was not enough water-flow for the eggs. We were told that we must dam the small stream two or three hundred yards upstream.

Bert Svanvik, Henry, Lee, Darryl (Wisam), Bill and other young men in the crew, cruised over to Port McNeill in the boats. They drove trucks to a small gravel pit a few miles out of Port McNeill and went to work loading bags full of gravel.

Once back in the town of Port McNeill, they moved the gravel bags to the small boats and transported them to the mouth of the river, where we were waiting to unload the bags.

The fog had burned off the ocean and I could see that it was going to be the beginning of a hot afternoon. By this time, we saw the boats rounding the mouth of the river, heading towards us.

After moving the bags from the boats to the riverbanks, each one of us flipped the bags on to our backs, then hiked up a trail that was about half a mile long and placed them on the side of the small stream for the future dam. I felt that I had to keep up with the rest of the crew, who were all men.

Henry, better known as Gee-Bee, kept looking at me before he headed up the trail. I immediately thought that I was not doing my share of work. With my back turned, I bent over as one of the men threw the next sand bag, filled with forty pounds of gravel, up and on to my back. Closing my eyes and trying not to think of the hill ahead of me, I used my free hand to wipe around my eyes before the salt from my sweat ran into them — this was a big mistake, as I almost let the bag slip! I quickly reached back as I realized this was a two-handed job. I began the long trek upstream to where the other bags were being put down. I passed Gee-Bee as he was heading back down and I thought, "Please take a break at the bottom, guy!" When I reached the bottom, Gee-Bee was heading back up and I went, "oh crap," in my head.

Gee-Bee and I were the oldest ones on the crew so we both had something to prove to the youngsters. This went on many times, and I was ready to collapse from heat exhaustion, stomach cramps and an aching back. Gee-bee passed by me and sweat was running

down his brow, and it surprised me that it could get by his nicely combed Brylcreem hair.

That weekend, I went out for a beer and ran into Gee-Bee. He said to me, "Why didn't you take a break?"

"Because none of you guys would," I replied.

We had a good laugh about that one because none of the men would stop because I wouldn't, and wouldn't because they didn't. All of us had stiff backs, legs and muscles because of the old male-female gender stereotypes that we thought we had to live up to, even though it was hard work.

The next day we were back on the job repeating the gravel bag toting upstream. It was about eleven in the morning and the fog was beginning to lift at the mouth of the river. As I stood in line waiting for my bag, I saw a crane standing on one leg on the far riverbank looking into the river for breakfast. The crane dropped his long, thin leg into the water and made a few small steps. His white neck bent downwards and his yellow, pointed beak dipped into the river and came up with breakfast.

Driftwood floating down the river had steam coming off it as the sun broke through and warmed the shoreline. My work clothing was wet and steam was starting to form on my shirt from my body heat and the sunshine. Taking a deep breath and exhaling, condensation made it look like I had released cigarette smoke from my mouth. I bent over and Lee placed a gravel bag on my back.

I started my slow walk up the hill and was more than halfway up when I heard a loud scream. Bushes were being pushed aside on the hillside and footsteps could clearly be heard running towards me. My heart started to race as I saw Gee-Bee running full speed down the hill with a look of fear on his face.

Without a second thought, I threw my bag down as he sprinted by me. I had never seen Gee-Bee run anywhere other than on a soccer field, so he had put the fear of God into me. I kept pace with him then passed him, my heart racing, thinking I was going to be attacked by a wild animal!

Both of us skidded to a stop on the riverbank, almost doing a header into the river itself.

We were so out of breath as the rest of the crew asked us what the hell was going on. My eyes were huge and I still did not know why I was petrified. I looked over at Gee-Bee, waiting for him to answer, because I still did not know why we ran down the hill. I thought he was going to say he saw a bear or a cougar in the bush. Imagine my surprise when he said, "I was walking back down the trail and I stepped on a snake! I goddamn hate snakes, ughh, ughh!"

"Damn you, Gee-Bee. I thought you were tough. What the hell? A garter snake made us run for our lives! I could see if it was a boa constrictor," I burst out laughing with the rest of the crew. I was amazed that a small garter snake had made Gee-Bee run like there was a bear hot on his trail.

Gee-Bee was never afraid to enter a barroom brawl or stand up for himself when needed; this was another side of him that I had never seen. It was strange to see him shake and wiggle from the waist up as he re-lived stepping on the snake saying, "Ughh, Ughh," throughout the rest of the workday.

Chapter Five

Water Experience

As the job went on, I came to realize that this one life choice at the mouth of the Nimpkish river would lead to many adventures crossing from Alert Bay to Vancouver Island by boat.

Mid-November of that very first year, we came home late in the evening. It normally takes twenty to thirty minutes, depending on what type of boat we were using. On this particular night, it was blowing, wet and very dark. The swells from the waves were coming into the boat and I was drenched from head to toe.

My heart was pounding as we hit every wave, turning us over to one side then to the other side, almost capsizing us each time. I have always feared drowning. I am claustrophobic and imagined sinking into the dark depths of the ocean. My hands were numb and I knew I would not be able to swim for long if we did flip over. I looked across and saw the lights of the bay, wishing that I was already standing on the dock that I could see from my precarious position.

All I thought about was the story I had heard about the Hanuse brothers, who were some of the first Natives to have their own logging company near the mouth of the river. Some of the brothers drowned trying to come across the river.

My Life With The Salmon

By the time boats could cover the mile or two to where they had capsized, it was already too late.

Then I thought about my Uncle Herbert, who capsized along with one of the Speck brothers. They both drowned on the same type of night we were now travelling in. Being an avid reader, my thoughts were here, there and everywhere, visualizing what drowning might really feel like. Was it really like going to sleep, like it was described in the books I read?

I remembered some fiction writer who made it sound like a nice way to die, but I could not imagine how swallowing salt water until my lungs could no longer handle it could be in any way pleasurable. When and how soon would my natural body instincts shut down so my throat would no longer accept the water, knowing it was going to hurt me? How would it feel to die because my body shut down and would not let me breathe, never mind let me drown!

I thought about the rats of the ocean eating at my body. I knew there were also all sizes of crabs and other critters that I used to pick on as a child. Life is a bitch, and I pictured those sea creatures that I used to pull the legs off mocking me. All I envisioned were the ocean's scavengers that would be waiting for me to sink below the surface. I would just be another delicacy served from above, who happened to follow the ocean currents to be served up on their dinner plates.

Damn all you writers, I wish you were in this small boat with me and we would live to tell about this experience. For me, now I would know how it really felt to experience the worst rather than just doing the research about someone drowning.

I could see the bay, even though it was nearly a mile away. I could see taxicabs driving by on the main street, and I remembered that Alert Bay made it into the Guinness Book of World Records for having the most cabs per capita for our population of about seventeen hundred. It is amazing what goes on in your head when you think you are facing death.

I pictured my dad going for a short cruise in his car, waiting to pick me up. My dad was probably worried and pissed off, wondering why we were not home yet. We finally made it into the safe harbour by nine-thirty that night, where the reserve was located. I climbed out of the boat and almost kissed the wharf because I was so happy to be ashore. I was shivering, and am positive that it was not from being wet and cold but from the fear of almost drowning!

I was right about my dad because he was waiting for me further up the wharf where cars parked. He did not say anything to me but I knew when he was mad. We were not wearing life jackets and should have waited for slack tide before making the attempt to cross the river.

Everyone and their dog who lives around the ocean knows that when it is slack tide the waves and swells will always be smaller, no matter how hard the wind is blowing. He did not say a word other than "Hi," but I knew that I would hear about it when he had a few beers in him.

I got up the next morning at six o'clock. My first thought was to not show up at the wharf, but what the hell would that do for women's liberation if I jammed out at my first real test, working in a field that is not traditionally a woman's job. So I dressed, packed my lunch and walked from my house to the wharf. I thanked God as I walked down the hill that there was not a breeze in the morning air.

Acting very nonchalant, I said, "Hey," to the rest of the crew, got in and sat in my normal spot in the boat. I counted heads and hoped I was not noticed doing this. I saw that we were all accounted for. I knew then that I had been officially accepted by the "boys" as one of the crew, the moment that I stepped into the boat. I had passed one of many tests that would come across my path.

My Life With The Salmon

Chapter Six

Doing What Comes Naturally

The next summer, the dam was working well and our fry were starting to grow. We had so far managed to handle all types of adversity, and we had finished the majority of the chores for that day. We sat down for a coffee break at two-thirty, and all we saw were sockeye salmon jumping everywhere in the river.

We all started to yell, "Look at those sockeye jumpers: inside sockeye!" It was a family thing to say, *inside* for when salmon was nearby and easy to catch, or had entered a net or our river. It was like we were kids once again, fishing at the mouth of the river with our parents. We started talking about how it would be so much fun to fish for one of the schools of salmon.

Wisam said, "The last bunch of people from home that came over for food fish left their seine net on the beach, just across the river." That was all that it took. Coffee and drinks were put down and all of us jumped into the two crew boats. I kept thinking, "We are going to get it for fishing, even though it is our traditional right." I knew that we should keep working but the mob hysteria bug seized me, too.

I may have been one of the oldest, with Gee-Bee, but I would like to try to see anyone stop a bunch of hormonal men bent on a

mission of going food-fishing. We have always felt and knew it was our right to fish for sockeye—or any salmon, for that matter—in our river when we wanted to.

Within minutes, we had crossed the river and landed on the island. The punt was pulled up to the small island that usually gets submerged at high water. Bert and the boys pulled the net on to it then placed another boat in front to tow the first boat along with the net when we saw salmon heading upstream.

Nothing showed for a half hour. I thought maybe we would come to our senses, but no. The salmon must have really wanted us to take them home to the Bay. Four salmon were seen jumping right in front of us. We all knew that sockeye salmon leap straight up and down, which they were doing. We yelled for the towboat to start, and it began to pull the punt with the net to make our fishing set.

Since many of the boys were seasoned fishermen, the fishing set went perfectly for the salmon, and we pulled in about four- to five-hundred sockeye on to the beach. Even though I knew what we were doing was wrong, my adrenaline started to rush and I was yelling just as loud as the boys.

Everyone ran into the river waist high and started to rifle the fish onto the island. "I think these are easily six to eight pounds each, guys," yelled Wisam.

"We should get at least a case of canned fish for three sockeye," replied one of the boys. I believed him because they were fishermen and knew their business. This reminded me of when I used to fish with my Alfred family as a child at this same river. I pushed back the fear of getting into trouble and just enjoyed the moment.

I was wearing track pants and a t-shirt, and was soaked from head to toe from the river as I rifled fish on to the small island. I did not care; all I saw was fish, fish and more fish. Fish scales were flying everywhere: on to my face, hair, shirt and pants. It felt so good to go and catch fish for our families, something that I had not done for many years.

The net was pulled in and put back in the same place we had found it. We then pulled both boats to the island and started to fill them with the sockeye. At four-thirty, we started across the river with both boats filled to the brim with fish and crew members. The closer we got to the Bay, the more afraid I became. How could we have caught the fish and still have been doing our jobs? Oh, shit! We are definitely going to get fired now!

Once again, Native culture came first. Our families saw us coming in, loaded down and barely moving, so they knew we had fish onboard. They went home and grabbed barrels, totes, buckets and anything else that could hold five fish or more.

To this day, I feel that our bosses and Elders would have done the same thing. The temptation to catch our fish would have been just the same for them as it had been for us. We never did get a lecture about the fishing set we had made. Also, a bonus was that we had to work the next day, so our families did the cleaning of all the fish, the canning and general clean up of the canning area, but we still received our share of canned fish.

Chapter Seven
NERP Twerps

After a few years of toiling at the mouth of the river, the whole crew received good news. We had become part of a new program called the Nimpkish Ecological Restoration Program, or NERP. Of course, since we were from Alert Bay and were a Native community, we needed a nickname for this new program. Everyone and every project seemed to have a nickname. We decided to call ourselves by the new handle, "NERP Twerps." We were given a decent budget. No more nickel-and-dime hatchery at the mouth of the river.

I was the lead hand of one camper vehicle with a crew of three. I had Lee, Gary and Wisam as my main gang. Bert was in charge of another crew of three, who would do lake fertilization data collection. The third crew was run by another woman. Verna was in charge of the last camper crew who would do river reaches along with my crew. Reaches were the process we used to measure by compass and hip chain the distance to the next corner of the river, which was not visible.

Our two campers would go throughout the 'Namgis territory and walk every part of the river system possible. Our job was to find out where adult salmon would hold in deep pools until it was time for the fish to move further upstream to their spawning grounds.

We had to also look for possible spawning beds that salmon may use, and any areas that could create a hazard for the fish to reach their original spawning grounds. Our information would go to others who would clear hazards such as logjams and mudslides so the fish could spawn.

Both our crews also looked for areas where we might be able to fish in the future. We had to fish for adult fish to get the eggs and milt (sperm) to fertilize at a hatchery, in order to bring up our fish numbers of Nimpkish fish stocks. Bert's crew had the job to go and take water samples from various lakes to see what type of zooplankton were in them and how many were in these lakes. Zooplankton is part of the initial food chain for the emerging salmon.

Plankton are organisms drifting in the water columns of oceans, seas and bodies of fresh water. Many zooplankton are too small to be seen individually with the naked eye. The crew would also take water temperatures and water samples from the top, middle and end of the five lakes that run into the Nimpkish River system. They would then send the samples to the Pacific Biological Station in Nanaimo to see how our lakes were doing.

We caught a BC Ferry from Alert Bay to Port McNeill on Monday mornings and came home on Friday evenings. "No more freaky rides home on a punt or boat in horrible weather," was the first thought that crossed my mind. Once again, that was another misleading thought on my part.

I spent the whole week in the valley. It sounded like fun until I found out there was nowhere to shower unless you jumped into the lake, weather permitting. The only place to use the washroom was the bushes, or the outhouses provided by Canadian Forest Products (CANFOR) in various campsites at the lakes, which were few and very spread out.

I realized that Lee, my cousin I used to bathe with as a child, had become a very different person. He was now a young adult male I would have to live with for five days a week as a twenty-something woman.

I also had never socialized with Wisam, even though he lived in Alert Bay, or Gary, who had recently moved here. They were also going to live with me in the same camper.

I almost thought that I could brave the waters from the mouth of the river to Alert Bay in the roughest weather once again, rather than sleep in those enclosed quarters with three men. To top it all off, I was the lead hand and kept thinking conflict would come up because I was female.

My Life With The Salmon

Chapter Eight
A Day on the Reach - August

I had the crew camper parked in front of my home and had to be the first one out of bed at five-thirty. Lee had nominated himself as one of the chefs. His father was a great cook who had taught Lee all his culinary skills. I picked him up first because he had all the meat in his deep freeze and he lived near me. We both ran around grabbing the vegetables and other refrigerated products and rifled them into our camper.

I was thankful that I had packed my work clothes, sleeping bag and pillow the night before because Lee forgot his. Because of his absentmindedness, I had to drive sixty kilometers or more, much like an Indy racecar driver, to get back to his house, get his gear, then zip back across the Rez to pick up the rest of the crew. On the way to the ferry, we stopped to pick up Wisam. Gary caught a ride down with his sister, Verna, who had another truck and was a lead hand in one of the campers.

The ferry left at seven-thirty and Lee started to set up his small kitchen, putting the grub away, all the while trying to see how all our gear was going to fit into the camper for five days. The rest of us went up top to the lounge on the ferry so that he had room to move around.

As the cooks arranged the three campers, the rest of us sprawled out and went back to sleep on the ferry's benches. This became a Monday morning ritual because we tended to make the most of our two days off, with plenty of nighttime activity with friends and family whom we no longer saw throughout our workweek.

The ferry finally docked in Port McNeill. It had to go to Sointula on Malcolm Island first, so it didn't arrive until eight-forty. The next stop for the three campers was the gas station then on to a hardware store to get propane for the stoves. As we headed out of town, we remembered that we had not gotten water for cooking and cleaning, so we turned around.

We were finally on the highway heading into the Nimpkish Valley by eleven o'clock. It hit me that this job was going to be a lot harder than I originally thought. We had yet to put our gear on and do any walking in the streams and the day was half over. We finally made it to Woss Lake. We had been told to do our first reaches from Woss Lake to the Woss-Nimpkish River junction.

Chapter Nine
The Day Officially Begins

We ate some sandwiches and packed ourselves some snacks for the hike downstream. I sheepishly watched the guys put on their neoprene chest-highs to make sure that I knew what I was doing.

A neoprene outfit can best be described as a two-inch thick waterproof pair of overalls that go from the chest to the end of your toes. The river boots that were bought for us were a size larger than our shoe size. I could not for the life of me see why our bosses had done this. My boots looked like an NBA player's pair of runners because I already had big feet for a woman. When I tried to pull them over the socked neoprene suit, I soon saw why they were a size larger. It was a struggle pulling the boot on and then yanking the chest high up and over my chest. I had never felt like such a rookie in all my life.

We waddled down to the Woss Lake river outlet. I felt big and awkward in the neoprene suit and boots. By the time we had put our feet into the river, it was already one-thirty. I was not the only rookie in the field so it was not surprising that we were not sure where to go, so we stood there and looked at our laminated map of this stretch of the river.

After a discussion that lasted around twenty minutes, we decided that we would walk downstream taking compass bearings, rock measurements, hip-chain measurements, river widths, and water temperatures until we had walked for three hours.

A hip chain is worn, naturally, across the hip. A black belt around the hip holds a yellow case that lets out a white line that closely resembles dental floss, but is a lot stronger. One person wore the belt while another brave soul walked downstream, letting the chain feed out to measure the length as he walked.

How you do this is as follows: you stop the person walking away before he is no longer visible and take the hip chain measurement, compass bearings, rock measurements and so on. At times, this person also had to cross dangerous, treacherous stretches of the river to get accurate river widths.

Lee had the hip chain on this particular day and yelled out the lengths for recording each reach. Gary was told to cross the river so we could get the river width while holding Lee's running hip-chain. Wisam took the temperatures, compass bearings, and rock measurements.

I was in charge of the wet book where all the data was recorded. A wet book, essentially a small binder with sheets of special waterproof paper, did not fall apart each time I fell into the river, and was best used with a pencil because the writing did not wash away like an ink pen would.

A wet book was supposed to be waterproof but it proved to be semi-waterproof, depending how often we fell into the river. One side of the page was where I would draw each river reach and the other was where I recorded all the data being yelled back at me. And I do mean, "yelled back," because once we were in the river, it was hard to hear each other. Needless to say, I was the first one to fall into the river.

My legs lifted up and I fell backwards. As I floated downstream, Lee reached out and grabbed me and said, "No fair; you have to walk with the rest of us. That is cheating. You cannot expect to

backstroke while the rest of us struggle here."

As I stood up and spat out the river water, I replied, "I wish it was that easy, you bugger." I was not used to wearing such bulky clothing. The shoes felt downright uncomfortable. To top it off, I was wearing a surveyor's jacket with all the pockets filled to the brim with pencils, wet books, snacks, toilet paper and drinks.

By the third or fourth reach we were still feeling each other out, but by the tenth reach, and an hour and a half in and out of the water, each of us was reaching our breaking point. By then, we all had slipped and gotten wet. I cannot even count the number of times we had to chase our baseball caps as they fell off our heads into the river.

None of us held back with cuss words and did not care who heard us. Sometimes the water was too deep to walk in and would have gone over our chest-highs, so we had to scramble on to the riverbanks. I bruised my knuckles and elbows on rocks, then scratched my arms on blackberry bushes and thimbleberry branches. Small pebbles and rocks found a way to get into the boots no matter how tight they were laced. The shoelaces came undone, even if they were double knotted, from the rapid flow of the river and sunken branches that snagged the eyes of the knots.

The worst problem was when I grabbed a handful of devil's club, because those thorns stuck worse than blackberry prickles. The variety of injuries included falling on my knees, along with the occasional hard knocks on my ass as I slipped and landed on boulders.

While all this slipping and sliding was going on, I still kept trying to listen for the sounds of bears and cougars that might be around. I realized that we were making so much noise as we fell, splashed, then swore as we picked ourselves up, that any wildlife within three miles had probably taken off, thinking we were some type of dangerous predator.

I laughed thinking that the whistle tied to my surveyor's jacket was meant to scare off bears. How was I supposed to blow the damn

thing when I was up to my neck in water at times and so out of breath that I would not have the oxygen to spit never mind blow the damn whistle?

I looked at my watch and saw that it was now three-thirty. Once we were out of the water, we sat on the rocks and listened to the sound of the river. We called a quick pow-wow and decided to take a break. We ate our snacks as the sun beamed down on us.

I had time to take a look around and saw we were surrounded by huge cedar trees. Gary was a big-time smoker and lit up a cigarette that he had placed into a waterproof container earlier. I asked Gary how he could smoke after all that back-breaking walking we just did.

With a smirk on his face, he said, "You will see why in a minute or so." Mosquitoes swarmed everyone but Gary because the smoke was keeping the bugs away. He looked over at me with a grin on his face.

The rocks and boulders in the river were worn smooth from the constant bashing they took from the currents. The river was singing us a song as it slowly worked its wet-polisher up and over the rocks. I now understood why we had such a hard time keeping our balance while in the river. If the boulders and rocks could not battle the current, we were not going to be a match for what nature was going to throw our way.

Even though I had fallen into the river perhaps three times, I was sweating and pulled the chest-highs down to my knees, which felt good for all of three minutes. During the initial minutes, steam poured off of my track pants and t-shirt. It had been a big mistake to pull the suit down because I started to get chilled very quickly as my sweat dried. The wind coming off the river quickly cooled my body heat and the wet clothing stuck to my body made me even colder. It was now four o'clock and we decided to turn back upriver to get back to our camper. I was so relieved, thinking that it would be much easier going upstream because we would not be doing data recording. For anyone who has never walked in a river, it is not easier going upstream.

A sports-fisher might laugh at us, but hey, they only walk off the bank and up to their waists, then back up the riverbank. I was pushed by the river flow and fell over many times. The wet rocks seemed to be one giant slide that I was trying to walk back up on. We had walked for miles downriver, then back upriver fighting the current. I did not know that I had so many cuss words in my vocabulary and I was learning a few new ones from the three boys in the river with me!

I finally saw the logging bridge that was just before the campsite and scrambled up the embankment. We followed a short trail that had been put into place for sports fishermen to use. Within ten minutes, I was sitting at a picnic table, taking off my red surveyor's jacket, peeling off that damn chest-high and boots, wishing I still had that cushy job packing sandbags at the mouth of the Nimpkish River. Both calves almost cramped as I tried to step out of the boots. I could not believe it was already six o'clock. I had been so happy that I had this job but it was much more difficult than I imagined.

When I peeled off the neoprene suit, steam came pouring off my wet track pants, t-shirt and socks as soon as the chest-highs came off. When my socks came off, my toes resembled a car windshield that had been in a major accident, with lines going in every direction possible because they had been soaked so long. I poured a cup of water out of each boot, along with pebbles and sand. This caused the bottoms of both feet to scream out their personal agony. When my toes were able to stretch and warm up, they really let me know how they felt about the treatment they had received that day.

I sat there on that picnic table totally exhausted, not caring that I was soaking wet from sweat and river water. I did not care how I looked and sat there thinking of how this was going to be one long summer if I was going to be in the river five days a week. I thought about how my thighs were going to develop and I would look like one of those Olympic discus throwers or weight lifters. I thought, "My God, I don't mind being a tomboy, but I sure don't want to look like one of the female athletes on steroids."

Now came the fun part for me. Being the only girl on the crew, I asked if they minded if I went into the camper to change first. Since it was early in the job, there was no problem. It was still summer and we were not cold. I leaped into the cramped camper and rummaged for a change of clothing.

This was very hard to do, since I was trying to keep our bedding dry and not get someone else's clothing wet. After I was done, the boys took their turn. I had to go to the washroom next, and thought to myself, "Would this day never end?"

I had never camped in my life, other than at a Christian camp on Kuper Island, located on Southern Vancouver Island, which had proper washrooms. I had stopped at the occasional rest areas on the highway and did not care for them. But I discovered that I would never complain about those rest areas ever again.

I stepped into the outhouse at the Woss campsite and immediately jumped back out. I stood outside the door counting how many seconds I could hold my breath. I could hold my breath for around twenty seconds, so I took a huge gulp of air and walked back into the outhouse. I think that was a world record time for me using the washroom in my entire life.

When I got back to the camper, Lee had booted Wisam and Gary out and started dinner. He asked if we had a can opener and, of course, the answer was no. He ended up using his knife to peel the aluminum lids off his canned vegetables. He started frying up some meat and I could feel my stomach growl. Lunch had been around one o'clock, followed by some light snacks, and it was now almost seven-thirty.

I had been on the go since five-thirty this morning and I was starved, tired and my face was starting to burn from the sun reflecting off of the river that day. All of us could not even sit in the camper because the heat was intense when Lee started to cook and boil the potatoes. I stepped outside to join the guys.

Wisam passed me the can of bug spray and said, "Put lots on because the little no-see-ums have been swarming me and Gary's

head for the last ten minutes."

Gary lit a smoke and we sat at the picnic table, shooting the breeze. I noticed that all three of my crew members were fair-skinned for Natives. I was the darkest of them all. Gary had dark eyes and pitch-black hair, my cousin Lee had light brown eyes with light brown hair, and Wisam had really light hair and grey eyes. We were all in our early twenties and in fairly good shape, so that would be an asset for the amount of walking we had to do.

Thankfully, dinner was ready in a half hour and we pulled a picnic table into the sunlight to escape the mosquitoes and flies. None of us said a word as we demolished our dinner and downed water because we were all dehydrated.

After we ate Lee said, "What the hell is it going to be like when the daylight hours become less and we all have to squeeze into the camper to change, cook, eat and lay down? It will be colder," he added, "and I love you but are we going to be able to get along without killing each other? We haven't even spent one night in the camper yet and it is already uncomfortable just moving around."

"You are right on the money with that statement. I like my own space and we will be in tight quarters a lot," I said.

We looked at each other and laughed, realizing it was funny now, but that was a reality we would all face in the three campers in the upcoming year. Not that we literally killed someone, but tempers did flare up and made work very hard for each one of us at some point.

We sat outside and played crib for a while, then we all started to get tired. Two of us went into the camper, did the dishes and cleaned up our little kitchen area. After moving inside, we sat around getting to know each other a bit better.

Wisam went to wash his hair in the sink but I didn't think he could get his big forehead wet, never mind his long, straggly hair in. He said, "What were they thinking when they designed the campers? The fridge and stove are the ugliest shade of green I have ever seen."

Lee laughed and said, "Well, the cupboards look like the standard issue that they install in our reserve homes. Cheap, brown wood with pretend knotholes that fool no one. Oh well, makes me think of home."

I knew Lee quite well and played soccer with Wisam's sister, Renee, but that was all I knew about him, that she was his sister. All I knew about Gary was that he had just moved to Alert Bay and was Verna's brother and that he had long black hair almost to his waist.

You could say that we were trying to bond in some way. What I got out of that first night around the little table was that we all drank alcohol, and that the three of them smoked cigarettes, and the wacky kind, also. We all played crib and none of us liked to lose.

None of us had known what this job really was going to be like. We were all happy to be working, getting good wages and to be working outdoors. All of us liked to cook, so that would not be a problem, and we really liked that the program paid for the grub.

Overall, it seemed like we could manage as a crew. All of us were worried about the winter months, the shorter daylight hours and the river flooding during the fall and winter months. If we were falling down now, what would it be like when the river started to rise a few feet and ran a lot faster?

After all the discussion, we decided on who would sleep with whom. I would sleep in the top bunk above the roof of the truck with Lee, since we used to bathe together as kids. Wisam and Gary would use the collapsible table bed and sheet cushions. Both were capable of sleeping two.

I made sure to go to the outhouse before I went to bed because there was no way I was going to go at three or four in the morning, flashlight in hand. After rolling out our beddings, lights were turned off. However, the old body let me down and I had to go at three-thirty just before daylight. I did not want to wake anyone else up but heard Gary get up to go outside. I told him that I was

right behind him. He waited for me to walk by him towards the women's outhouse and went in the bushes a few feet away from the camper. My grumbling thoughts were, "Why couldn't we have similar plumbing as the guys so I would not have to walk all the way to the privy by myself?"

After getting back into bed, it seemed like the alarm went off as soon as I fell back to sleep. I looked over and it was only five in the morning. I hit the snooze button for an extra fifteen minutes of sleep but that was not a luxury I would get that day. I turned over, wishing I could sleep longer, and thought that there was a leak in our roof. I was sleeping nearest to the side of the camper. The condensation from the four of us had wet my sleeping bag and pillow. Of course, Lee had to say to the guys that he thought I had peed the bed. And another day in the Nimpkish valley started for the crew and me.

Chapter Ten
Second Day in the Valley

Lee and Gary started to cook our breakfast. Wisam and I went to the outhouse while Gary folded up their bed so we could get our table back. Then we had to line up to wash up before we ate. After we had all eaten, we made our lunches. We knew that our day would be longer than yesterday. It never ceased to amaze me that Lee still called sandwiches, sangwiches. We would correct him but he never changed to the correct pronunciation.

Wisam only made one sandwich and I asked him why. Our grey-eyed Native answered me in his slow way of talking, "I am never hungry for a couple of days after being out on the town. I will be eating better come Wednesday or Thursday." I thought to myself that I would quit going out on the weekend if it affected me that much.

Dishes were done and the garbage disposed of as we put our wet chest-highs back on along with the surveyor's jackets. It is an awful feeling sliding into a chest-high that is damp still from previous use. After checking to see that all gear was packed and ready to go, we set off back down the Woss River. This time, I packed a change of clothing and runners inside a large Zip-loc plastic bag. This was carefully secured on to the back of my surveyor's vest.

39

Everyone did the same thing after that first day. They were nicknamed our "fall in clothes." It became one of the first things we packed, even before our lunches. If we were far from the camper, we had to walk an extra three or four miles over the brush to find a logging road. We found out that this was often easier than walking back upstream.

Once we were on the road, it could easily have been another mile of walking to where we had last left our camper. This was when the clothing was the first item to be pulled out.

Walking on a logging road with wet chest-highs and boots was a minor inconvenience, but to be able to put on a dry t-shirt and a sweatshirt with a hood was a godsend. We just threw the chest-highs and boots over our shoulders and hiked along. It made for easier walking and the wet gear dried on our shoulders while we were on the logging road. This was especially true when the sun was beaming down on to us.

A hoodie kept the mosquitoes off our arms, neck and head. Being in the dry clothing also brought our body heat higher, and gave us relief from the clinging chest-highs and water-logged boots. I think all the talk about the shorter daylight hours made us all think about maintaining our body heat later in the day when we started to get tired.

After two days on the job, we were starting to adapt to the situations we were going to find ourselves in, but didn't realize it at that specific time. Our walk to the river along the bank on the second day started at six in the morning and ended at seven at night.

After reaching the camper, the day before felt like it had been a walk in the park compared to the miles we had put in on day two. By the time we hit our bunks, it was eleven in the evening. As soon as my head hit the pillow I was out, and I did not budge until I had to go to the outhouse at five in the morning.

Chapter Eleven
Rainy Season

This was how it went each week until October of that first year as a NERP Twerp crew member. October brought its own problems. As we had feared, the shorter daylight hours made our work a lot harder. Our workday started when we could see and we had to end it earlier as it became dark.

They do not call the north end of Vancouver Island a rain forest for no reason. It rained almost daily and we were drenched as soon as we stepped out of the camper to outfit ourselves in work gear.

If the rain did happen to let up for even a few minutes, our bodies were swarmed by hundreds of mosquitoes. I actually started to prefer the rain rather than hear the constant buzzing of the pesky blood suckers in and around my ears. They often ended up in your mouth. The bites made one scratch one's arms, face and neck all day long.

The river was also a major problem during the fall and winter months. We were on the middle of the Davie River one time, having entered by the Davie Bridge near the Schoen Lake turnoff from the highway. We started at seven in the morning, with the water just above my kneecaps as we stepped in and started our downstream hike.

After walking until noon with the relentless rain slapping us in the face, the river pushed us from behind with a ferociousness I had never felt before. We had a short, half-hour lunch break and decided to head back upstream.

On this particular stretch of the Davie, there was no logging road near the river so we had to struggle back upstream. It was a battle as soon as we entered the water. The Davie River had massive boulders with many steep banks that were inaccessible from the water.

There was hardly any walking in the bush beside the river. I fell down four or five times in an hour, often wondering if I would be able to get back on my feet. Many times, the guys had to stay behind me to help pull me back up. Each one of us fell in a few more times as the afternoon progressed. As we moved upstream, Lee yelled out that the river had risen a foot or more that day. I felt fear instantly, since I knew that we had not even reached the halfway point to where we had entered the water. Time was becoming a factor because darkness would soon be upon us.

By four-thirty, we could barely see ten feet in front of us because of the dark shadows and the constant downpour. Our depth perception was being taxed to the limit. When the rain let up a bit around seven o'clock, I heard highway traffic in the distance. We then heard a truck go across the Davie Bridge roughly one hundred yards in front of us.

When we finally reached the bridge, it was seven-thirty. I looked down one last time before I climbed out of the river and saw that the water had risen from being just above my kneecaps to almost covering my breasts! This meant that the river had risen over two or three feet in less than twelve hours.

It had taken us five and a half hours to get downstream and seven hours to get back upstream. I was so thankful that we had not gone any further than we had or we might have had to climb into the brush to spend the night. We had no equipment that would get us through the night other than what we were wearing.

The next day, we went back to the Davie Bridge and the river had come up another four or five feet.

"Holy crap," Wisam said, "you can't even see any of the boulders that we were walking on."

Gary commented that we could probably float downstream in a raft to where we had finished off the day before in less than an hour. Lee tested this by throwing a large stick into the river on the upstream side and it whipped by us and around the first bend in a matter of seconds.

With not much discussion and plenty of common sense, we decided to go to the smaller river by Anutz Lake where our river reaches could be done safely. All our fears about the river flooding were coming true, and this was something we learned to take into account on a daily basis.

Every Friday Wisam would sarcastically remark, "My God, we smell like we have been on a fishing boat for weeks on end. I can't even stand my own odour, and I feel bad for the rest of you guys." We all reeked to high heaven and it would have been hard to differentiate between any of us. And we always looked like crap when we got on the ferry.

Whenever possible, we tried to save enough boiled water to at least wash our hair, but a sponge bath was out because it was too cold. The times when there was enough water were few and far between, though. It got to the point where we would all sit in the back of the camper on the ferry, rather than have people move away from us in the upper deck lounge. None of us wore hair gel but by the end of the workweek it looked like we did. We resembled dogs left out in the rain too long.

Chapter Twelve
Caught by the Baz

We were all camped out at Woss Lake. It was the first time that all three campers were there at the same time. Our valley is so big that this rarely happened. Each camper had an agenda that had to be followed. Because all three campers were in the same area that day, the three cooks pulled out the best meat possible and we had one heck of a barbeque.

As we all took turns using the outhouse, one worker named Vannie kept throwing rocks at the outhouse when we least expected it. It made each and everyone jump, then throw curses back at Vannie as he laughed his head off, thinking this was so funny.

We all decided that after dinner we would buy some beer at Woss. We would not go to the privy until Vannie went first. He got up to go and we circled the outhouse, rifling rocks as hard as we could. Of course, he was up on the hill looking down at us laughing because he was ready for us. Talk about looking foolish but so typically Vannie!

The next day, all three campers started working at four-thirty a.m. because once you woke up and had to use the outhouse, everyone was awake. It was a small area we lived in. All the campers split up and went in three different directions. Before we separated, we said, "Let's meet at Mine Lake for another barbeque."

The place we were planning to meet at was an artificial lake. It used to be an iron mine. The water was so deep and warm because it did not come from the mountain runoffs but from rainfall and small side streams. Those who have grown up around the ocean, and learned to swim in the ocean, know why it was such a pleasure to barbeque and go swimming in such a spot.

We quit working at three in the afternoon and headed for Mine Lake for our rendezvous. The steaks were sizzling and everyone was taking running dives into the lake. Everyone was shampooing their hair and taking a much-needed bath in the lake. An airplane flew low over us and we all looked up and waved at the plane.

Someone said, "Wouldn't it be funny if that was the Baz flying by us?" The Baz was our boss. We laughed and said, "Yeah, right!" Then we started diving into the lake once again.

However, it was not so funny because it was the Baz flying by with the Department of Fisheries and Oceans (DFO) people. These were the people who gave us the funding for what we were doing. The Baz was so-called by all of us because it was short for Basil. It also reaffirmed that he was the boss.

He was so pissed off at us until we explained that we had started very early and had all ended the workday at the same time. It was so hard being in the valley from Monday to Friday. We needed to break up the monotony of the workweek. He finally understood that we needed to socialize with others besides the same four crew-members in each camper.

He had been a logger when he was younger and understood how others can grate on your nerves. He knew that if we did not see other people, problems would eventually arise. One such example was the great onion versus mushroom battle that happened one week.

Lee did not like mushrooms in his cooking and he always threw them out when he saw them in the camper. This really irritated Wisam, who then proceeded to rifle out our onions.

Wisam said, "If you won't cook with my mushrooms, then go to hell. You're not cooking with onions either."

This led to heated actions and words, but the boys finally settled on cooking with two separate pots when the recipe called for either mushrooms or onions. It came up whenever we were overtired or just in a bad mood, especially when it was nearing the end of the workweek.

Chapter Thirteen
A Hard Day Working with the Baz

Our crew had a meeting and my boss, Basil, told me that I was going down the lower Nimpkish River with him. The lower Nimpkish River is approximately five to six miles long from the lake outlet to the mouth of our river that hits Cormorant Channel. Our Elders called this stretch of the river Gwa'ni, hence the name of our hatchery.

We got to the lake outlet and the rafts were lowered down by Kilpala Bridge and then placed into the water at five-thirty, just as dawn was breaking. Basil and I were in a two-person raft. The rest of the crew was sitting pretty in an eight-person raft. I thought to myself, "Oh, shit! I am in for a ride from hell."

The big raft took off with the majority of the crew and all that was left was Basil and myself. I was slim and trim at this point in my life. Being an active soccer and basketball player kept me in peak physical condition. I jogged daily, coached a women's soccer team and trained on the soccer field three times a week.

Basil sat in the back-end of the two-person raft. He said, "They have quite a head start so we had better catch up."

I looked back as I paddled my ass off while he sat there with his rifle slung over his shoulder looking around at the scenery.

We started to hit the rapids and I was smaller than my boss. My half of the raft bounced up and over the boulders but the Baz got lodged on to a rock.

"Geez, Honey, you had better get out and get us off this rock," he said, much to my chagrin. Because of the difference in our body weights, I glided over the water but the Baz sagged deeper in the water and the raft lodged itself on some rocks.

I was almost chest-high in water and walking upstream to lift my boss over the rock that the raft was stuck on. Once I leaped back into our little raft, the Baz saw some ducks and pulled that rifle off his shoulder and started shooting. My ears were ringing from the sound of the gun.

"Go get them or they will sink!" he yelled.

This was really going to be a day that I would never forget. I chased the goddamn ducks as the Baz placed the gun back over his shoulder. He was more than willing to let me chase the ducks, do the paddling, and dislodge him from the rocks and boulders. I finally saw the larger raft in front of us and come "hell or high water," I was determined to catch up to the rest of the crew.

Both rafts were almost to an area in the river that everyone calls "Dead Man's Canyon." You can take the easy way or get drenched going through the roughest part of the river. Basil said to go left and in my mind I was thinking, "I don't think so!" I took the right-hand side, where the river was really running, because I was not going to be pushing anyone over a rock in "Dead Man's Canyon." We entered the fast flow of the river and the wash was coming up and over the bow, drenching the Baz and me. His moustache was hanging down and looking pretty droopy.

It was a rush barrelling down this stretch as we bounced up and over boulders. Baz put his paddle in the water for the first time and was yelling, "Hard left, okay now switch to the right." My boss was wearing his favorite hunting hat that resembled one used on an African safari, but now the sides that used to curl up nicely were hanging limp, much like his black mustache.

We made it over the canyon okay but the Baz looked pretty pissed off at me.

I thought to myself, "Fire me, but at least I am still here to be fired." He never did fire me but I never had to go on a two-person raft with him again, which I thought was a bonus.

Chapter Fourteen
We all have a "Baz the Boss" Day

It was time to go fishing down the lower Nimpkish River once again. We were heading for Asi'wa'yi ,the small island that is just above our Indian Reserve #4. We left in three trucks, loaded down with the rafts, nets, fish stripping gear, buckets that we would use to carry the eggs we stripped from the females, lunches, fall-in clothes, and Ziploc bags for the male fish milt. It was early and we could barely see each other as we loaded everything into the rafts on Nimpkish Lake. Clouds of warm air could be seen coming from everyone's mouth and nose, since it was a cold December morning.

I looked up as we slowly started to paddle downstream and saw the three drivers heading back up the logging road in the warm hatchery trucks. I wished that I had been a driver that day because it was so cold. There was a numbing winter mist drifting up and over the river as we floated past boulders and sunken logs. We passed by Indian Reserve #5, U'dzo'la's, which is less than half a mile downstream.

I started off feeling cold but once I put some muscle into my paddling, I quickly heated up and started to look around, enjoying the scenery. Within ten minutes, we were passing over hundreds of dog salmon suspended less than two feet under our rafts and

paddles. This one stretch of the river had one squirming mass of salmon heading upstream to the spawning beds of gravel and rock. I was mesmerized by the scene I saw swimming underneath me. The fish looked huge and seemed never-ending. When I looked skyward, I was amazed to see hundreds of eagles perched on branches, waiting for their chance to feed on floating salmon eggs that were not quite buried by pebbles and rocks. They would also feast on dying and dead salmon carcasses that would eventually overflow on to the riverbanks.

We finally hit a deep-pooled area and the fish were no longer visible but I was still re-living what I had seen. I could only imagine what it must have been like for my ancestors who witnessed the previous generations of salmon, those salmon ancestors to the ones I passed over today. It seemed fitting that I was there because I am a 'Namgis member, and the 'Namgis people have fished this same stretch of river, generation after generation. The fish were also from the same stocks that had been there for generations of 'Namgis people.

We floated around the next corner, and Bert spotted a black bear sitting in the shallow side of the river. The bear casually looked over at us and continued peering into the deep pool on the other side of the river, trying to spot the elusive salmon. As we floated by, the bear swam out and into the river to chase down the salmon that would provide his winter fat. Around the next sharp bend we came across five white swans. All of us pulled our paddles out of the river and let the downstream current carry us along so we would not scare them into flight. The swans gracefully floated with the downstream river current but as we got closer, they took flight and were gone around the next bend in the river.

We came around a few more corners and once again spotted the same group of swans. The birds replayed the same graceful floating and flight pattern into the air. I thought back on how I wished I had been a driver that day, and was now so happy that I was not. The images of fish, animals, birds and the beautiful fall background that I saw, will forever live in my mind. I could put up with the cold as long as I could see the things that I saw that day in the early

morning mist, as daylight finally cracked over the treeline.

We continued to head down the river and reached the island in roughly an hour. All the gear was unloaded and put on to the island. The boys nailed pieces of two-by-four into trees to be used for hanging racks. Nails were banged into the boards, for these racks would be used to hang the females by the tails. Once they were hung up, the gills would be ripped out so that they could bleed out. Blood cannot get mixed with the eggs because this will ruin the eggs for fertilization with the male milt later on.

Bert and the crew headed below the island and placed a net across the lower end from treeline to treeline. The corks were soon bobbing in the current and the web line billowed outwards and downstream. The lead line sank quickly and sat atop the rocks below. The other half of the crew was at the top of the island getting the other net ready. I was with the crew at the top end of the small island. We stood four or five feet apart on the island and we had a section of the cork, net and lead line in our arms as we marched out across from the island to the other shoreline.

Bert and some of the guys started to throw rocks and bang the water with sticks, herding the salmon downstream past us where we stood motionless. I saw so many chum salmon swim past my legs as the boys scared them downstream. Once Bert saw that we had a fair size school of fish going into the two nets, he yelled out: let your lead line down, gang! We dropped the lead line, the web floated downriver and we all held on for dear life on to our sections of the cork line.

As we stumbled, tripped and occasionally fell down, we walked towards the other net that was stretched out below the island. We had managed to catch a good haul of dog salmon inside this net and I could clearly see the reddish-green coloured fish swimming in all directions, trying to avoid the web, and I could sense the distress that they were feeling.

The men quickly mended the two nets together and we start to pull this new net that was now one towards the island. I stood in the river holding the cork line up so that the fish could not leap over

while others pulled the lead line in nice and low so the fish could not get out below the lead line. Others were slowly pulling in the webbing up on to the beach. We had made a nice shallow bag with the net near the island, and Wisam and some of the other crew start to grab the females.

Bert, Lee and the others quickly reached out and placed tail harnesses on to the females and gave them a death-blow to the head. I thought this was harsh when I started this job but then remembered that these same fish would die a slow death after they had spawned. It eased my conscience a bit, since this seemed more humane. They then tore out the gills so that the fish could bleed out.

As this was going on, the rest of the crew were taking the males and piling them ashore underneath a tarp that we had hung from trees to take the milt. The males were grabbed by the tail and head and gently massaged from the upper part of the belly towards the tail. Milt came squirting out and into the baggies that others were holding on to. I heard the occasional curse word as some blood or bile came along with the milt, which meant the person had to discard the baggie because it would ruin the fertilization process if it was not pure milt.

The tarp was hung up to keep out the rainwater and mist because that also started the milt off on the fertilization process even though there were no eggs around the milt. While I was standing there holding the cork line up, all the things that I had learned in the aquaculture course came back to me and I was in awe of how nature can do the things that it does.

The crew released the male fish back into the river outside of the net so that they could still go and reproduce with other female fish. These same males would die after they had finished fertilizing the eggs, then become part of the food chain for the young fry that would eventually emerge from the gravel beds in a few months' time. The male fish were eventually removed and we moved ashore and took the female salmon off the nails.

I had the job of using the stripping knife, which I used to gut the

female from the anus up the belly, and then reached in and gently shook the eggs out and into a bucket. Lee held the fish by the gill area and pulled the tail back so that I could get a good cut. My hands were freezing but I was very thankful that I was no longer standing in the river. I sat on a fallen log and stripped three females per bucket. I slammed a lid on the bucket so that it sealed any moisture out, because this would also cause the female eggs to spoil. No moisture must touch the eggs until we mixed the milt with them at the hatchery further downstream later in the day. All the female carcasses were thrown back into the river to become food like the dead male salmon.

Other crew members were doing the same thing that I was. After this was done, we got back to our workstations in the river and repeated the whole process all over.

We left in our trucks at five in the morning and were finally finished at five in the evening. The eggs, milt, gear and equipment were packed into the rafts and then we started downriver again.

After twenty minutes of paddling, Basil saw a seal in the river. I thought to myself, "Oh no, here we go again!" I was right.

Baz pulled his rifle off his shoulder and said, "Go towards the seal, guys." The chase was now on and Baz was going to get that seal, come hell or high water.

"Whoo, that seal looks like a keeper, gang! It's going to taste so good after I skin and cut her up."

Baz was brought up with Elders and was one of the few who still ate seal meat. I often wondered what seal tasted like but was in no rush to try one of the olden-day food staples. We got in shooting range and Baz took aim and shot. I lay as low as possible as he let go with his first volley and then let go with another bullet. I was thinking, "I don't get paid enough for this shit!"

The seal rolled over and started to head downstream with the current. Now Baz was really yelling at us to start pulling on the oars.

We were all putting everything we had into the paddles to catch the damn seal. After fifteen minutes of hard chasing, we were close enough to the seal and Baz made us turn the ass end of the raft around so we could pull the seal aboard the rear end of the raft where there was less equipment. Three of the guys reached over and started to pull the seal up and over the stern.

I thought to myself, "Like we aren't overloaded enough, we have to take this seal back with us." The seal's head was the first thing to come aboard; then all of a sudden the seal opened its mouth and its eyes popped open.

Talk about seeing a bunch of Indians move so fast backwards and sideways. Baz pulled his rifle off his back again and he took aim! "My god, we are on an inflatable raft and our boss is going to let loose with the bullets again," was my thought as I rolled as far over the edge of the raft as possible.

My heart was racing, thinking that we were going to float the rest of the way downriver hanging on to pails and parts of a deflated raft. He let loose with a shot but the seal had dropped overboard and sunk below the waterline. The seal never resurfaced and I quickly looked around to see if there was air pouring out of a hole anywhere around where the seal had been lying.

Talk about seeing your life flash before your eyes. I pictured being shot, drowning, eaten by one angry seal, or freezing on the riverbank on this cold December night in a matter of a few seconds. I can laugh about it now but I have never died in so many ways in a matter of seconds. This job had managed to make me think of dying on the ocean and on the river too many times now.

Thankfully, the rest of the trip went uneventfully for the next half an hour, but the Baz still had his eyes peeled looking for that seal to resurface. I was so grateful that it did not because I did not want to go and chase it again just to have the Baz shoot a hole in the raft the next time around.

We were twenty minutes away from reaching the pickup spot by the hatchery truck drivers near the mouth of the Nimpkish River

when our long day decided to throw us another curve ball.

We rounded a corner and it was really dark now. It had blown heavily the night before and a tree had fallen across the riverbank right where we were headed. I was in the third row paddling when I heard Bert yell, "Duck, duck!" After everything that had happened today, I knew Bert didn't mean a Mallard duck and I did not have to be told twice. I leaned back and knocked into the two people behind me as they lay back, also.

Nathan, who was in the last row, didn't react fast enough and he was knocked overboard by the falling bodies and the tree leaning out over the river, just as we came into one of the last rapids in the river before the pickup spot. We all heard the splash as he hit the water and someone behind me yelled that he had grabbed on to the line that we carried the raft up and down the riverbanks with. I looked back and in the little light we still had, I saw him bouncing along in the rapids, up and over some huge boulders. He had a death grip on that piece of rope and as we reached the calmer stretch of the river, the crew reached over and pulled him up and over the lip of the raft.

Within one day of work in the river, I learned great respect for the current and the power of this river that we called our own. The river taught me that it has the power to give life and take life in an instant. It could be salmon, bears or one of us, but we had better pay the river the proper respect it was due for we could easily be gone in an instant if we were not careful.

Chapter Fifteen
New Experiences

As the years passed by, we were moved from crew to crew to learn new duties. On this particular workweek, I was sent to the lakes crew with Bert. I had learned respect for the ocean, the river and now a new lesson was about to begin on the lakes. There are many lakes that flow into the Nimpkish River on the north end of Vancouver Island. I always thought the lake crew had a great job riding around on a riverboat throughout the year.

Never assume, because there's that saying, "Never assume, because you make an ass of you and me." I quickly learned that the lakes crew faced all sorts of obstacles and lucky me, I had to be taught respect for this body of water, also. Nature never lets me down and, once again, I was in the open water facing wind, rain, sleet and snow.

The lakes crew had to take the samples at the top, middle and bottom end of the lake. They had to take water samples from different depths, then preserve them in formaldehyde. These samples were sent to Nanaimo for testing to see how much zooplankton was in each sample and what type they were. Zooplankton is one of the first parts of the food chain of salmon.

Bert took us to Nimpkish Lake first and the day started off fine as we put the boat into the water at the top end of the lake. It took us an hour to get to the bottom end of the lake to take the first set of samples. I was thoroughly enjoying the ride as we took zooplankton samples from different depths and placed them into water bottles. We then headed back to the middle of the lake and did the same thing.

The crew decided to pull into the Karmutzen River outlet and take a break for lunch. After getting under a huge cedar tree, we ate then lay back for a while, digesting our meal. By this time, it was two or three in the afternoon. I wondered where the word Karmutzen came from because it looked like it was part of our language. I now know that it comes from the word Kamadzina, or waterfalls, when translated.

Bert warned me that the wind usually picked up about now and I thought nothing of this. One would think I knew better by now. We started to take the last bunch of samples and the wind and waves really picked up. I could barely see because of the rain, the wash of the waves coming over the bow and my nervous sweat, as I had a flashback of all the other times I had been in rough weather on the water.

Bert had just told me while we were having lunch that Nimpkish Lake is one of the best wind surfing areas and I could see why. Windsurfers from around the world use the south end of Nimpkish Lake. Surfers camp right by the lake on the west shore, right where we had launched the boat.

The place-name in our Kwak'wala language is Numas. Translated, Numas means Old Man. After asking certain Elders why this was so, they said, "Numas, or Old Man, means dangerous. One must be careful when travelling past such areas."

Our boat was not very big but Bert and the other guys did not seem afraid, so I tried not to look scared but was failing miserably, sorry to say. I was beginning to think that all of Nimpkish Lake should be called Numas.

We left on a calm, misty morning less than three miles away and now I was hanging on for dear life as four- to five-foot swells washed over us, pushed us left to right and then side-to-side. The boys pulled up the water samples as Bert tried to hold the boat in position so that we rolled with the waves and made sure no one went overboard. I was never so happy to see the last sample taken and hear the small motor make the sound of its full power being utilized.

Once we reached the upper part of Nimpkish Lake and turned into where we had launched the boat, which was directly across from Willow Creek, the wind died right down and the waves became smaller and smaller. After one week with the lakes crew, I was no longer envious of the rides on the boat that they had. Give me the river any time. I could reach out at any point and feel grounded or swim until I made it to a back eddy if I fell in the water. I knew that I could not swim in those swells in any of the Nimpkish Valley lakes if we had ever been swamped when the winds decided to blow along the mountains on to the lakes.

Bert told us the next day that we were going to Woss Lake but were going to do something different. Our marching orders were to go and see if there were any sockeye carcasses in and around the Rugged Mountain area by the glacier stream.

I have since learned that Rugged Mountain is in the Haihte Range. I called around to fluent Kwak'wala speakers to find out the traditional name because I read that it meant fish head. There is a word, Haxte', from our language that does mean fish head, which further verifies our use of the valley for years. Reflecting back now, I can see the mountain peaks resembling a fish head to our Elders. Most of our names in the valley come from what they looked like or resembled.

I accidentally said out loud, "Oh shit, that range is on the other end of Woss Lake and it is wintertime."

Bert looked over at me grinning, and asked, "What's the matter, not enjoying the lakes crew job?" That is when I realized I had spoken out loud.

It took us an hour and a half to get to the top end of the lake. Bert pointed out Rugged Mountain to me and I could not believe the waterfalls coming down from the peaks. The closer we got to the shoreline, the more entranced I was by the glacier falls.

Bert slowed the motor and I could hear the water cascading down the hillsides. We coasted along the shoreline and managed to spot some carcasses before they had a chance to slide down into the depths of the lake.

Bert said we had to walk partway up the small glacier stream and do a quick spot check to see if any fish had gone further up. I stepped out of the boat and on to the beach. This was my first time at the glacier. It was a beautiful greenish-blue hue that was so different from the rest of the rivers that flowed into the Nimpkish River system.

Within minutes of stepping into the glacier stream, I felt icicle pins and needles through my boots and chest-highs. As we walked up the glacier creek, I saw half-eaten salmon heads hanging in the bush where an eagle had dropped them after all the meat was taken off.

While walking on the sides of the stream, we came across more carcasses that bears had scooped out and eaten, then left on the riverbanks. There were so many blown down trees, I realized that the wind must really howl through here to cause these huge trees to fall over and across the stream. I treasured this moment, even though the stream was so cold, because I did not know when I would ever be back to this part of the valley again.

I would more than likely be back with the river reach crew next week and I wanted to enjoy each moment spent in this breathtakingly scenic part of Woss Lake. As we left the top end of the lake, I sat facing the glacier as it faded in the distance, and I hoped that I would come back here again.

Chapter Sixteen
Shared Memories

My cousin Lee was working with the hatchery crew when our hatchery moved from the mouth of the river to Willow Creek on the Upper Nimpkish Lake. The crew worked hard shifts and one person always had to stay over the weekend when the rest of the gang went home. It happened to be Lee's turn and he had a girlfriend who spent the weekend with him.

It rains a lot in the valley and Lee's weekend shift was no exception. To get to Willow Creek, you had to launch a boat and go for twenty or thirty minutes across the lake. You then had to tie the boat high up the creek bank. It was another five- to ten-minute walk up a hillside, then down to where the hatchery was located.

After Lee had picked up his girlfriend, Alva, they tied the boat as high up the creek as possible to a tree. It continued to rain Friday night and the creek rose almost two feet.

Lee told Alva that he had to go and check on the boat or else it might float away. She swore at him up and down, begging him not to leave her alone. At the same time, she was afraid to walk down to the boat in the dark. The end result was Lee went by himself to check on the boat.

It was dark, wet and slippery but he made it to the boat just before the tie-up line broke from the tree. He pulled the boat ashore and fired up the motor in an attempt to head further upstream. Lee tried and tried for over an hour to get to a place where he could tie the boat but the creek kept pushing him out and down to the lake. It reached the point where he could not even make landfall and had to run the boat over to the other side of the lake where the boat launch was.

I happened to be on the ferry heading to Alert Bay and was very surprised to see Lee in the lounge upstairs. I asked him what was going on and he told me what had happened. I quickly asked him if Alva knew that he was not going back to the hatchery that night and he laughed. He called her from a pay phone and she swore at him up and down, saying, "Get back here! I am not staying here by myself overnight."

He told her it was impossible and said, "Don't worry. The generator will stay on and there is a rifle there if you need it."

She more or less told him where to go and then asked, "Why would I need a rifle?"

I knew that Alva was afraid of being alone, especially at Willow Creek because you are totally isolated and no one can reach you without the use of a boat. Alva ended up calling Hank, who was the boss of the Willow Creek workers, and demanded that a helicopter come and pick her up. The Baz had moved on to other work opportunities and Hank was now in charge of salmon enhancement. Hank explained that it was too expensive and they would not fly in the dark. The helicopter was just not an option, and Alva ended up crying on the phone.

I knew that bears frequently came by the living quarters and the site was really isolated. Lee had blatantly lied to Alva. He told Alva that no animals came around and the lights would stay on. The generator turned off on a time switch and she would be left in the dark.

Hank told her how she could go back outside to turn the generator on and Alva really started to bawl, saying "I am not going out there with a flashlight to turn it back on!" Hank then told that her only other option was to keep her flashlight close by and use the Coleman lamps until the fuel ran out.

Alva made it through the night but I can only imagine what her thoughts were. She did not work in the valley and was just a guest. When Lee showed up the next day after the water levels had dropped and he was able to make it back up the creek, he was lucky she did not shoot him because she was so mad and upset. She demanded a ride back to the other side of the lake and a ride back to Port McNeill. Lee later told me that was one of the few times Alva did not talk other than to curse him.

I asked him if it bothered him and he said, "No, it was actually nice not having to listen to her yell at me any more."

Chapter Seventeen
More Willow Creek Adventures

The crew had been working at Willow Creek when they were told that one of the members had hepatitis. Each and every one of them had to come to Alert Bay to get a preventative shot. My brother Joe was one of the first ones sitting in the waiting room just around the corner from the Community Health Nurses (CHN) office to get his shot.

Another cousin and crew member, Morrie, was pacing outside in the waiting area and asked him how and where they would get the needle. He really did not like needles. Joe told Morrie, after he got his shot, "It doesn't hurt, just drop your pants and tell them to pick a cheek."

Diane, the CHN came out and called Morrie. He walked in the room, dropped his pants and bent over. He then proceeded to tell her to pick a cheek. Diane and the other CHN, Sandra, burst out laughing as they lifted his shirt and then gave him his shot in his hip. Morrie came tearing out of that room after he had pulled up his pants, looking for my brother Joe. Joe was sitting there waiting, laughing so hard that tears were coming from his eyes.

All Morrie could say was, "God damn you Joe! You got me again!" Morrie could only laugh along with him because he had once again been taken in by one of Joe's practical jokes.

The crew had quickly adapted to using humour. It was a way to deal with the isolation of working at Willow Creek, where one spent so much time away from family. The isolation and time away from home caused many family problems. That was a constant problem for the crew because we actually spent more time with co-workers than spouses.

Chapter Eighteen

Back to Willow

Joe and Morrie were the first ones to leap off the boat at the mouth of Willow Creek. There was a new crew starting to work at the egg take that year. The new guys struggled up the small hill with their sleeping bags and clothes. They could not understand why Joe and Morrie were sprinting up to the cabin, bags and all.

Both Joe and Morrie were seasoned workers at the site. They knew that whoever made it to the cabin first had first dibs on the semi-private two-person bedrooms. The only ones with reserved spots were the bosses. New guys, or newbies, had to sleep in a larger room with people who snored and read until the wee hours with the light on, and did not have the comfort of a platform bed with a mattress!

The days were long and hard. It was a treat to have privacy even if it was with one other worker. The crew sometimes worked seven- to ten-day work shifts that often were fifteen-hour days.

You were stuck on the other side of the lake totally isolated unless you went back by boat, then by truck on a logging road. This only got you to the Island Highway. It was still another fifteen minutes to Port McNeill.

The boat was only used for work purposes so one could not just jump in the boat and head across to visit people in Woss or McNeill. I was fortunate not to be part of this crew because I did not know if I could have handled the long hours or a weekend by myself in total isolation.

Chapter Nineteen
October Enumeration Crew Work

Wisam and I were chosen to go with the lakes crew while the other boys went looking for a place to fish in the lower Nimpkish section. Bert brought us over to the Woss campsite.

"Get your wet gear on, guys. We will be in and out of the water all day," he said.

All of us made faces as we got our suits from the back of the crew boat. The suits smelled of sweat, fish, mildew and old fish blood. Wisam got out a can of air freshener from the camper and sprayed us all down, but to no avail.

"Get used to the smell on them babies because we are going to be using them from now until late December," Bert laughed.

"It will be cold and hopefully we won't smell the suits as much," I said.

"Yeah right, we will be stinky, wet, cold and miserable with slimy fish scales all over our faces, hair and hands," Wisam cheekily replied. One thing about Wisam, he could sure make you visualize the worst aspects of your job.

Bert told me to head down the short trail to see if there were any sockeye carcasses from the lake outlet to the bridge. He then took the crew boat to the boat launch area further up the lake. As he drove off, he told us he'd see us in half an hour. He was going to check the oil and fill the gas tanks before he came back to get us at the campsite.

Wisam yelled at Bert as he realized something important. He told him to stop, because we needed to get the kit out of the camper to do the otolith and scale samples. An otolith is more or less the ear bone located just behind the eye socket of the fish.

Bert slammed on the brakes and even though it was October, a great cloud of dust blew back into our faces from the road. "I swear that if your heads were not permanently attached, you guys would forget those too," he said with a grin. We sheepishly grabbed the gear we needed to sample the sockeye salmon and started for the lake outlet.

"Hey, look. There is one right there," I yelled as we reached the beginning of the trail.

Wisam walked into the water up to his knees and grabbed the dead sockeye and brought it back to the bank. I was carrying the POH (post orbital high pearl stick), which is used to measure the fish from behind the eye to the tip of the spine bone.

There is another measurement called a nose/fork measurement. This is different because you sometimes find fish without a tail. You need to measure from behind the eye to the back of the spine. I wrote down the measurement in our wet book while Wisam opened the kit. He grabbed out tweezers and the book that we would put the scale samples into.

"Damnit! I forgot my glasses in the camper," he said.

Yep, we were lucky our heads were attached all right. I grabbed the tweezers from Wisam because I was wearing my contact lenses that day and could see what we had to do. I bent over the fish and grabbed one scale from the right side of the fish.

Wisam had the book open and I placed the scale right side up into the book. If placed backwards, the sample would be no good. I then flipped the fish over and took a sample from the other side and repeated the process. I yelled out the number from the book so Wisam could record it in the wet book beside the fish length.

He then grabbed the other booklet that would hold the otolith sample. He got a small knife and slit between the eyes, nose and mouth to the back of the eyeball. This was so I could reach in with the tweezers to get the otolith out. I carefully placed it into a little pouch especially made for the otolith, as Wisam recorded this number into the wet book.

The otolith is used to tell the age of the fish. It also tells how long the fish was in fresh water and how long it stayed in the ocean. I guess you could say it is similar to a ring around a fallen tree that tells a tree's age. A scale sample does the same thing but it is not as accurate as a otolith sample. Both types of samples were taken because sometimes we would come across a dead fish with no head and we could only take the scales.

We continued on to the bridge but saw no more dead fish, so we turned around and went back to the campsite to wait for Bert to pick us up at a small wharf there. We sat down and Wisam promptly lit a cigarette and opened a can of Coke to quench his thirst.

"Ahh, I love that burning sensation when you chug a big mouthful of Coke," he said.

Within minutes of sitting on the wharf with our feet dangling over the edge into the water, we heard the roar of the outboard motor coming around the bend with Bert and Bill. The two of us stood up and made sure we had all the necessary gear in our hands before we boarded the riverboat. I filled Bert in about the one sample found so far and we zipped across twenty feet or so to the campsite where we spotted 100 to 150 swimming salmon in a deep pool. There was not a salmon carcass in sight so Bert turned the boat around and we headed south down the lake to where we knew the salmon spawned.

After having been out on the weekend drinking a few beers, Bill commented, "Gotta love that lake breeze in your face, hey gang?" Our huge smiles and grins on our faces were more than answer enough for Bill.

Within twenty minutes, we were at one of the main spawning beds and we saw 840 to 860 salmon, which was a fair-sized school of fish at this area. It was one squirming mass of red-coloured sockeye, and males with hooked beaks, all along the shore.

Bert dropped Wisam and me off and we walked the shoreline looking for carcasses. We found two and repeated the process once again. Bert yelled at us to stay where we were. Bill and Bert saw one a bit deeper there and would use the pipe pole to pull it up and then bring it to the shore.

After sampling the third fish, we got back into the boat and headed further down the lake to the next spot where we knew the sockeye spawned. This ride took approximately forty-five minutes so I sat down and enjoyed the scenery around me.

It was overcast but it did nothing to my mood because the Haihte Mountain Range was in plain sight. I could see Rugged Mountain in the distance and was happy to be going back to the small glacier stream again.

As we rounded the last bend, I saw that the glacier was not flowing very much because it was beginning to freeze at the top of Rugged Mountain, but this still did not spoil my joy in being at the top end of the lake.

We got out of the boat and found a dead fish right near where someone had previously camped. I could clearly see the charcoal and ring of rocks around the remnants of a fire. This fish was intact so we took the necessary samples.

Bert had us walk up the stream for a bit. We walked in the icy, cold stream for twenty minutes and came across two dead ones but they were unusable. Predators had already had a feast on the rich salmon found in the stream.

Another salmon was hanging in a tree branch that looked to be five feet in the air, with only bones left and part of its tail barely hanging on to the spine section.

One more carcass was found at the beginning of the Grease Trail to Tahsis, which was also unusable. We were lucky because on another small side channel, we found two usable sockeye.

After all the sampling was done, we noted as we walked back to the boat that there were still twenty spawning salmon at the extreme south end of the lake. There were also maybe another fifty sockeye trying to get into the main channel by the glacier stream to reproduce.

Bert asked me to draw a map of what we saw today and where the carcasses were sampled. I quickly opened the wet book and proceeded to do as asked while it was fresh in all of our memories. As I was doing this, the boys opened up their lunches and answered any questions I asked them about where on the map we had seen the fish. When I finished, I opened my lunch.

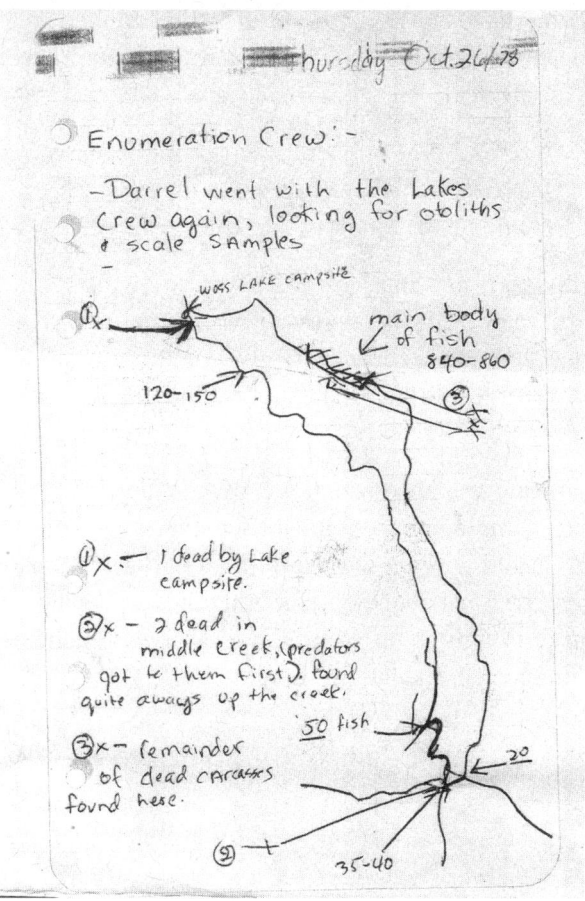

Wet book sketch from 1978 Enumeration Crew

I noticed that all the fresh air and walking made one very hungry. As I ate, the smokers lit up and sprawled out on any flat area that they could and just listened to nature.

We could hear eagles talking, ravens cawing, splashes of female fish digging a redd in the riverbed and males swimming by as they released their milt on to the females' eggs. A redd is a hole dug into the riverbed where the female salmon places her eggs and males will fertilize the eggs. The female then covers the redd with rocks and stones to protect them until they hatch.

I walked over and watched one female swim by, time after time, using her tail on one of the scooped-out areas to cover the precious cargo that would be in the riverbank until they were ready to emerge as young fry.

When we were ready to get back into the boat to head back up the lake, each and every one of us were careful not to step on any of the redds because the eggs are very sensitive. Our body weight could crush the eggs, never even giving them the chance to reach the eyed stage and a future life of four to six years.

While we headed back to the campsite I watched Rugged Mountain, the waterfalls, and the Haihte Range fade into the background. All the hard work we had to do was more than made up for when beautiful scenery was seen at the end of most workdays. I often wanted to pinch myself because I found it hard to believe at times that we were paid to do the things we did.

Chapter Twenty
Education Dollars at Work

After a few years, I went away to another education institute, this time to Camosun College, based out of Victoria. I took an Applied Communication Course where I had hopes of getting a job in journalism. I quickly found out that it was not going to be easy to find a job in journalism, so back home to the Bay I went again.

I was depressed because I could not find work in the new field I had chosen. There was still a hatchery crew on the river but it was now at Cheslakees campsite on the lower Nimpkish River. I decided to go back and do what I used to do, so I called Bert Svanvik and Hank to see if there were any jobs available. They both said sorry, not until after broodstock time in September or October.

I was walking down the road in front of the local grocery store and saw a job posting for four people to work for the other Native reserve on the island. It was posted by the Whe-la-la-u Band office and one position was for a lead hand who knew the Nimpkish valley, salmon species, logging roads and river systems. I figured, what the hell, and submitted my resume.

I had all the qualifications except for two specified requirements. One was to live on the Whe-la-la-u reserve and the other was not anyone under the age of twenty-five.

I thought, if I get shortlisted, I might have a chance. I ended up getting called in for an interview and was very surprised at who was there.

Bert and Hank were now in charge of the hatchery and they were on the hiring committee. Now I felt that I had a really good chance for the job. The position called for salmon fry identification and river reaches that I had knowledge about. The hiring committee took turns asking questions and I ended up answering the next question before it was asked. The reason for that was because one question led to another topic that I knew about. Bert said, "I guess there is no need to ask this question, you have already answered it." Then Hank and Bert sort of chuckled along with me.

I ended up getting the lead-hand job. I had a crew of three to oversee: Patsy, Robert (Bingo) and Ross. Hank was now the Head Manager and Bert was the Assistant Manager of the Gwa'ni Hatchery and would be my bosses this time around.

Chapter Twenty-one

A Day as "Fry Recapture and Reach Worker"

We stayed at the hatchery in the living quarters Monday to Friday. All meals were paid for and we were supplied with one crew cab truck. This was a bit better than living in a camper truck throughout the week.

Ross loved his cooking, soccer and hockey. I do not know what order he preferred them in but he would go and sit in our company vehicle faithfully each and every night that the Vancouver Canucks played. Actually, it was always Canucks, cooking and soccer, in that order. He would sit out there in the truck no matter what the weather conditions were. The radio was always tuned to 980 AM just for that reason. Ross loved his Canucks so much that even when they lost he was very upbeat, never failing to say that they would win the next one.

Each and every morning, we woke to Ross cooking up a man-sized breakfast for us. He would cheerfully say, "Rise and shine. Breakfast is on." There were usually pancakes or French toast with bacon, sausages, hash browns, brown beans and toast. Coffee was always ready. "Eat up, gang. We all know it is going to be another long day," were the type of words that we came to know from Ross early in the wee hours.

I was once again wearing the chest-high suit and boots. We started every day perhaps one hour before daylight and piled into the truck for the forty-minute drive up the Nimpkish Valley.

Our job was to find landlocked salmon fry that could not reach the main river systems and place them back into the main river. We had to capture them with dip nets and salmon fry traps.

The species that we usually captured were coho, sockeye and various types of trout. After capturing them, we measured, identified and released them into the main side stream, river or lake near where we had caught them. All data went into a computer database for future reference. This type of job took us into all of the side channels throughout the Nimpkish Valley.

Many times we had to walk for a mile or two past brush and rough terrain to reach the areas where fry were landlocked. We also had to reconstruct river reaches in certain areas to see how much the river had changed since the last survey.

My crew started on the Davie River to do river reaches to see how much the river had changed direction, if at all. We started at the mid section of the Davie River by the Schoen Lake turnoff on the Island Highway. I suited up in the cold morning air at six-thirty, which was too damn early in my mind.

My breath started to send little wisps of condensation up and above my head. We walked, fell, scrambled and recorded all the data needed for the Davie River reaches. This section, and all of the Davie River, for that matter, is very steep with many embankments and barriers that we had to cross. Many other hatchery workers including myself called the Davie River "Boulder Alley," which was a play on words that meant bowling alley. Our "bowling alley" threw curves at us. If one went the wrong way, one could end up in the gutter, which was either side of the river. A head pin meant that you had nothing to grasp on because you were in the middle of the river. If you did not make the corner pin, it could mean your life.

The corners of the river were always the deepest because this is where the river gushed as it poured out from all the lakes and rivers in the upper reaches of the Nimpkish Valley. Miss the corner and it could be possibly game over for you in literally the most important game of your life.

A few hours later, we broke for lunch at a beautiful spot on a huge logjam on the Davie River. The sun was shining down on us and all we heard as we sat on a comfortable fallen hemlock tree were the birds chirping around us and the sound of the river running by below us. I looked up and saw one of Canfor's logging bridges towering above me. All of a sudden, I heard a rattling, clunking sound.

The bridge was three storeys high above us, and I saw a train towing many loads of logs of all sizes and species. They were being moved to the sorting area on the ocean that would eventually travel many miles away to Beaver Cove, which was on Johnstone Strait. The train took five minutes or more to pass and the noise was thunderous, drowning out the peaceful sounds of the river. No matter how far we went into the valley, it seemed, humans influenced and ruined what was a moment of quiet and peacefulness just seconds before. At four o'clock, I decided that it was time to turn back to our truck.

Rather than struggle back upriver, we decided to cross the river and head for a logging road that we knew was there. After a hard day on the job, we looked up at a huge hill on the opposite side of the river and, damn it, that was where the logging road was! I grabbed a long stick that looked strong enough to support my weight.

Entering the Davie River, I tentatively stepped into the water with my stabilizing pole to hold me up if the current tried to push me over. I looked back and saw that all three crew members were doing the same thing. I made it across safely and looked back to make sure that the others did, also. After stumbling over the huge rocks and boulders on the riverbank, we headed up the steep hill.

I was stunned at how wind could push over these huge trees that I had to climb over. There were all types of trees that had been blown over, and many times I had to grab hold of that damn devil's club, with its many prickles that would pierce your fingers. It is a plant that grabs hold of you and will not let you go.

I know now that it is a medicinal plant used by our Elders. It is hard to believe such plant was medicine because it was so hard to be around it.

I did not know that Patsy was afraid of heights and we were in our chest-highs climbing a hill that had a gradient of seventy-percent or more. Patsy was very feminine in the way she dressed, walked and generally carried herself in everyday life. In other words, she was very different from me.

Bingo, the gentleman that he was, stayed behind her and made sure that she did not fall. He pushed her when she needed it and Ross was in front reaching back with his hand to make sure that she made it up the hill. I was in front of them and kept telling her not to look back down the hill. I could see the fear in her eyes. Patsy told the boys, "Please don't let me fall back down!"

Ross talked to her calmly and told her not to worry, saying, "I am in front of you and Bingo is behind you."

After climbing for fifteen minutes, we reached the summit of the embankment. Patsy was so relieved to get to the top of the steep hill. She leaped over the last log without looking to see what was on the other side. The next thing we all heard was a crash of bushes, rotten logs and stumps giving way as Patsy started to roll down the other side of the hill. She let out a girlish scream that frightened us all. Thank God, it was not as steep as the climb up and she ended up hitting a large stump that stopped her dead in her tracks so that she did not fall all the way down the hill. She had rolled for fifty yards before she sat there looking at us with a stupefied look in her eyes. We could all hear her groaning and saw that she was staring at her hand with a look of fear on her face.

Ross raced down the hill and saw that she had cut her left hand on some sharp branches. Experience working in the valley had taught me to always have first aid material on hand. We pulled out the kit and disinfected her hand and placed some Band-Aids on it.

Patsy said "I feel so silly for just jumping over that log without looking to see what was on the other side."

Being the lead hand, I realized that it could have been a lot worse. I decided that Ross would always lead us when heading up, out, over, or through bushes when we were not walking in the river. He was the fastest, the most agile and would survey the trail in front of us so that this type of accident would not be repeated.

Bingo told us, he would always stay behind Patsy or in front of her if it looked like the way might get a bit hairy. Patsy looked at him with relief in her eyes and Bingo became her knight in shining armor in the valley from that moment on. As I quickly learned, Patsy always worried about her latest love all day long, Ross talked constantly about anything and Bingo more or less listened and did his job. Our personalities were very different but we learned to gel with each other on and off the job.

Chapter Twenty-Two

Another Day as Lead Hand of the Whe-la-la-u Crew

We had to do the Nimpkish-Woss River Junction again and my first thought was, "Oh, shit!"

I had done this stretch many years ago and thought to myself, "What the hell, how much could it have changed?" Boy, oh, boy, that damn river sure can change, and it surprised the hell out of me. Even though I was so experienced, so I thought, and knew what to expect, it still took us two days to do all the reaches on a five-mile stretch of the Woss River. We started from the Nimpkish River, three miles from Woss Logging Camp.

This one spot we named "Poacher's Dream" usually had over 4,000 sockeye holding until the river started to raise and run. These fish would then move upstream to their spawning grounds. It was a hot summer day and we grabbed sticks that looked sturdy and gingerly entered the Nimpkish River. The water started to climb past our knees, then up to our waists.

The Nimpkish River is deceiving because of the crystal clear colour; everything looks so close when you lose your depth perception. We were bracing ourselves with our sticks to fight the river current that was trying to push us over. I could not believe that something

so clear and beautiful as the river could be so powerful. It felt like the river wanted to possess us like the water it pushed downstream, to be our master and us its willing slaves.

The river inched over our chests and we were on the edge of our toes trying to keep the water out of our chest-highs. It is surprising how often you pray when you never think about God until you feel the water start to push you over, and then all you can think is, "Why did I never believe in God? Is it too late? Will he still accept me if I wasn't a regular church attendee? Do my prayers count and will he hear them? Will he even listen to me?"

All that and more ran around in my mind. The next thought was, "How long will these chest-highs keep me afloat if I lose my balance? How fast will the water fill the lower parts by my feet and make me drop like an anchor to the lower depths of the river and never allow me to come back up to the surface?"

When we finally did reach the other side of the river, God went out of my mind and I never mentioned to my co-workers what I had been thinking. I felt like a heel for only thinking of the Lord when I felt danger, and promised myself that I would try to rectify this way of thinking.

There were only ten spots on the river that I recognized from walks in other years. I feel that was because these sites were on an exceptionally beautiful area with high embankments that were not affected by flooding that caused the riverbanks to change.

Huge hemlock trees occasionally blocked the sky from our view. Cedar trees could be seen with their drooping branches. The occasional wild animal trail was spotted near the berry bushes and fallen trees. Red huckleberries and blue gooseberries gave life to the greenery that surrounded us.

The area was too steep for the loggers. They had not had a chance to fall the trees and ruin the pristine river and the awesome views. Much later, I would see these same trees cut and heli-logged out of the valley. To see those helicopters flying out trees that I thought would be safe hurt me deeply.

I would never again see magnificent trees like that in those areas.

When we finally finished the final part of the river, Patsy was bagged right out and couldn't go further. Ross and I decided that Patsy and Bingo would stay where we had finished the last river reach, which was at the Woss airport. It was all gravel, but level. It took the two of us almost two hours to get back to our start point where we had left our vehicle.

Just before we reached the Woss-Nimpkish River junction where we had to cross the Nimpkish River, we saw something that was totally unbelievable. We looked up and saw a huge, five-pointer elk crossing the river no less than one hundred meters in front of us.

Ross whispered to me, "Don't move." My first thought was, "I don't think you need to tell me that."

It was a magnificent sight to see but very frightening at the same time. The elk had a nice, brown sheen throughout its body and a snow-white collar and big brown eyes that were looking right at us. The elk gracefully walked midway across the river, then stopped dead in its tracks.

We were barely keeping the water out of our neoprene suits, which was just below neck level because the river was so deep. The elk had barely crossed the point above what I would call past his knees. I was scared and Ross told me again not to move. Christ, I heard him the first time and had no intention of moving.

We stood there motionless, hoping, praying that the big buck would not attack us. Now I thought, "There I go again. Now I am swearing and praying at the same time to the person who I am asking for help." The elk stood there staring us both in the eyes, if that was possible, no BS! His mate walked by him and covered the other half of the stream, then stopped. Now, I was really scared. The two elk covered the whole width of the river and both were still standing motionless but not taking their eyes off us.

We heard some more rustling in the bush and three little baby elk crossed the stream behind their parents.

Ross and I gave each other that look that meant "Do not move or we are dead!" After the three babies crossed the river, the mother crossed, leaving the father, while both of them never ever lost eye contact with us. Ross and I were complete statues. I swear that the two of us could have been two rotten stumps in the river that day.

After the elk family was safely across the river, the father elk leaped in one jump, well over five or six feet, and was out of the river where we could no longer see him. We heard some bushes crash and break as the family of elk went on their way. My heart finally slowed down to its natural rhythm and I finally had the nerve to turn my body. I took a deep breath and felt such relief that is impossible to describe.

My thoughts were everywhere. I wish I'd had a camera with me, then I knew that there was no way that I would have pushed the button for fear of that subtle noise setting off that father elk into attack mode.

I thought of being thrown ten to fifteen feet in the air by those huge antlers or being stepped on by the hooves of the adult male. I visualized being stomped on by the mother's hooves as I slowly drowned in the river. I pictured my ribs being crushed by the antlers and hooves on the shoreline of the Woss River. I looked at Ross with a dazed, astounded, and stunned expression. These emotions were running rampant through me.

"Did you see the way he crushed the bushes as he leaped out of the water?" I asked him. "That could have been your face or mine if we had pissed him off! Did you see how far that bugger jumped and he was not even using his antlers to break the bushes open?"

As we walked for the next twenty minutes, all we could talk about were those elk. After that adventure, everything else seemed like nothing as we continued on and finished walking the rest of the Woss River. Ross and I crossed the Nimpkish River and even though it was treacherous in places, it was very anti-climatic after the elk encounter. We were happy to get back to our work vehicle so we could take our gear off and talk about the elk.

Ross grinned at me saying "I can hardly wait to tell Bert and the other guys that like to hunt about how close we came to that big sucker." He went on to say, "I wish I had a rifle with me. But that buck was sure big. I don't think I would have had the heart to shoot it."

"How do you think we would have crossed the Nimpkish River if you had shot that elk?" I laughed, adding, "I would never have been able to lift it with you. If we had made it as far as the river, we would never have floated the beast across. We can barely stand up ourselves, never mind pulling an elk alongside us."

"Yeah, you're right," Ross agreed, "we would have never been able to get it across without a big raft or something. And if we left it overnight, scavengers would probably get at it."

We could barely contain our excitement and we relived the moment over and over as we went back in the truck to go get our co-workers. Once we drove to where the other two were, both of us were trying to tell Pasty and Bingo about what we had seen that it ended up coming out in a flurry of gibberish. They finally told us to slow down and tell them about it one at a time, but our words could not do justice to what we had just seen.

Patsy said "I would have loved to have seen that, but I bet I would have had a heart attack if I got that close to them. Thanks for not taking me with you, today."

I had never seen an elk other than in photos before, and it is a memory I will treasure forever and a moment in time that Ross and I will always share.

My Life With The Salmon

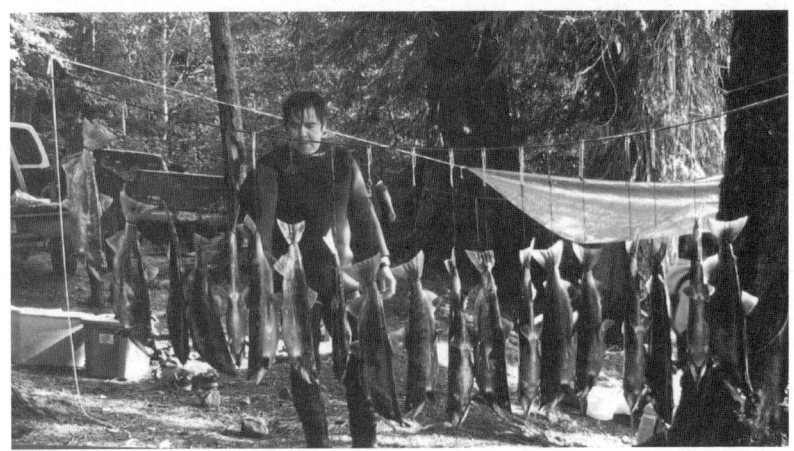

Phil Alfred hanging female Salmon

Taking out the Salmon Otolith to determine age

Diane Jacobson

Showing otolith size to scale

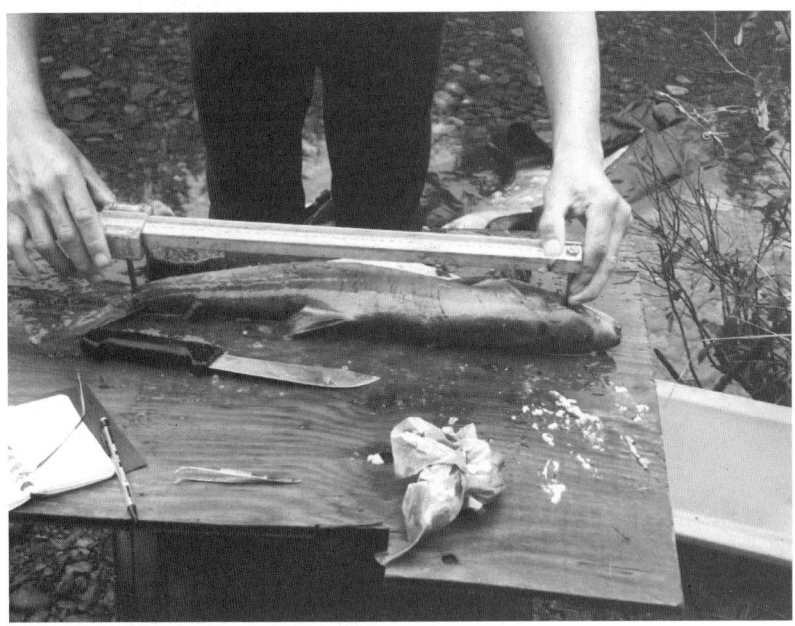

Fish measurement and scale samples

My Life With The Salmon

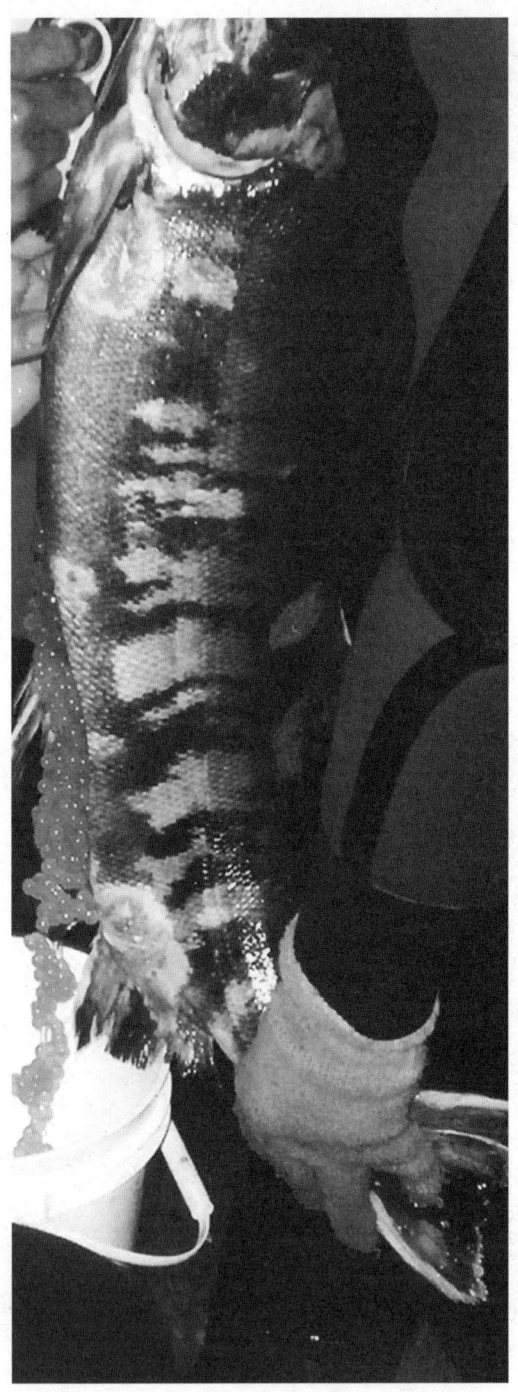

Stripping female chum of eggs

Diane Jacobson

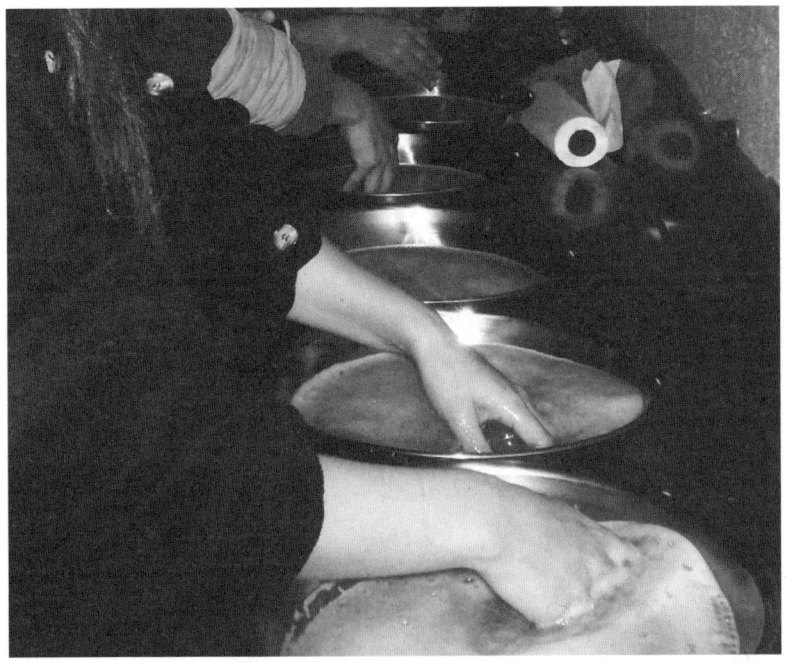

Stirring milt and eggs to fertilize at hatchery

Chapter Twenty-Three

Lukwa Creek River Reaches

Ross, Patsy, Robert and I went to the railway tracks near Woss village at seven-thirty in the morning. We parked the car and started to walk along the tracks that transported loads of logs to Beaver Cove.

We followed the tracks along until we came to the canyon area that looked down into Lukwa Creek. Ross started to walk to the centre of the trainbridge because he was curious as to how high it was above the creek. Bingo yelled, "Hey Ross! Hope you remember the movie *Stand by Me*."

"That is not even funny, you guys," Ross laughingly replied, adding, "the odds are slim to nothing that a train will come along."

Sure as the sun rises each day, we were taught another lesson this day. Ross was no sooner heading back to where we stood on the bank waiting for him when we all heard the clatter of the logging train heading towards us.

All of us were yelling at him to "Hurry, hurry! That sounds really close." I remember praying to myself, "Please Ross, do not lose your balance. Make it safely to the end." Ross started walking fast, then faster and he started running. He stepped off the bridge with seconds to spare as the train passed by us.

I felt the wind from the train, heard the wheels and for a split second in my mind pictured Ross being crushed under them.

We all stood there laughing but knew that it could have been a very hairy situation for Ross with nowhere to go. The creek was not deep enough to jump into and even if it had been a deep river, Ross said, "I don't think I would have survived jumping off. Geez, I would have broken my legs or my neck."

After we sat there discussing the close call, we started down the steep embankment. If you have ever seen a mountain goat come down a steep incline, that was us, but much less graceful. Rocks started to loosen underfoot and almost hit the person below.

I encouraged Ross to go first because he could find the safest and easiest way for the rest of us. I would follow him until there was a secure spot that we could hang on to. Lord Bing (Bingo) would follow next and make sure that he looked after Patsy.

Ross thought that was a good plan. That way, the person below would not be in danger of falling rocks as we headed down. It took us most of fifteen minutes to do this safely.

Lukwa Creek runs into the middle Nimpkish River and our orders were to do river reaches from the junction of the two systems until we hit Highway 19. After safely navigating the climb down from the bridge, we walked for five minutes until we came to the junction of the Nimpkish and Lukwa Rivers.

It was eight-thirty in the morning now and it was starting to warm up into one of those hot summer valley days. Ross lit a cigarette while we discussed who would be doing what. We decided Lord Bing would wear the hip chain, and Patsy would record all the data and map the creek. Ross would walk to the nearest corner and yell the lengths out to Patsy. My job was to measure the incline of the river, say what type of tree coverage there was and give the data to Patsy.

We were doing our first river reach by nine.

We left the hatchery at six in the morning and Pasty couldn't believe that it had taken this long before she could finally write information into the data book. I told Patsy that she better get used to it because I know from experience working with Bert and Verna that this is the normal routine, not the exception.

She rolled her eyes saying, "Oh well, if this keeps up, my Sweetie at home will find no love handles to tease me about. I should lose my cute beer belly by the end of the summer." We laughed along with her and began the long trek up Lukwa Creek.

Ross and I led the crew and were pleased that it was a hot summer because the creek was not deep. "Hey, this beats walking the Woss River. We are only getting wet from the knees to our waists. There are no huge boulders like the Davie River. The current is almost nonexistent," Ross said.

I was thinking to myself, "Never, ever think anything is easy." Sure enough, the Lukwa was like a huge anaconda snake that curled this way and that way. By lunchtime, we were not even one-quarter of the way to the bridge. Patsy was cursing that she hated these damn mosquitoes. She stated that she thought she just swallowed two the last time she opened her mouth.

We took a twenty-minute lunch hour because we knew we still had lots of creek to cover. Once we started again, our legs were getting heavy and Patsy slipped into the river and water ran into her neoprene suit. "Oh my God, that's cold! I'm okay, guys, but you know what, that was actually refreshing," was how Patsy responded. Patsy was becoming a bona fide hatchery worker. When she started, she would have gotten hurt and cursed the water, the rocks and anything that was near her.

By the time we could hear the roar of cars and trucks passing on Lukwa Bridge on Highway 19, it was going on six.

"Hey, hey, hear that? We are so close, gang. Let's get the data recorded and step it up," Lord Bing said. Smiles broke out and we were like the Energizer Bunny from television. There was happiness once again amongst our little group.

Crash, crash, back to reality! Sound carries so well over water and the forest that we had been deceived by the vehicles. "Next corner for sure," Ross commented, as he tried to keep morale up. It was one hour later and we still could not see the bridge.

It was now seven o'clock and we finally saw Lukwa Bridge a hundred feet in front of us. Cheers went up from all four of us. "We did it! We did it!" Patsy said.

We finished off the last river reach measurements and started to climb up the embankment. I said to Ross, "Don't tell the other two but we have at least a five-mile walk back to our truck on the highway, then the logging road."

I realized then that the other two did not care. They pulled off their suits and changed into dry t-shirts, socks and runners. We felt relief to just carry the neoprene suits and boots over our shoulders. Passing vehicles stirred up a nice breeze that cooled us off. The bugs were no longer swarming our heads and five miles of walking on level, dry ground was a piece of cake compared to the day we had just put in.

An hour later we reached the truck and threw our gear into the back. As lead hand, I asked Ross if he minded driving us back to the hatchery. I was bagged and afraid that I might fall asleep at the wheel. It was now eight o' clock and the sun was dipping behind the mountains.

Ross said, "No problem, but do you mind if we stop at the Woss Gas Station?" Patsy was thrilled, she wanted and needed to wash up and really needed to use a real toilet. Lord Bing agreed to stop and to get something cold to drink and some snacks for the ride to the hatchery.

After our pit stop in Woss, Ross turned on to the highway. I vaguely remember listening to the crew talk about the day but was asleep in minutes. I woke up when we reached the hatchery turnoff, which is gravel rock and bumpy. I looked at my watch and saw that it was nine forty-five in the evening.

We had gotten up at five when day was just breaking and had one of our chef Ross's magnificent breakfasts, and were back at the hatchery when the sun had already disappeared behind the trees.

I was dying to have a shower but had no energy, so I let the rest of the crew go first. I plopped down on the couch and had a nap because I was so beat. It was going on midnight by the time Patsy said it was my turn to get in the shower. As I walked towards the shower, Patsy said, "Getting out of the shower's not going to be easy once you are in it." The smell of shampoo and soap was out of this world.

As I walked by her, I smelled the clean aromatic odours wafting off her body. I laughed as I saw her wrinkle her nose when we came near to each other. I still smelled of stale neoprene suit and sweat. Oh well, I would come out of the shower looking and feeling as good as Patsy in a few minutes.

When I finally put my head on my pillow it was the next day. Needless to say, I was out like a light in seconds. I normally dream but I have no recollection of anything until the alarm woke me again at five in the morning. I was thinking, "How many days can we survive without killing each other with only five hours of sleep each night?"

Thankfully, days like that one happened approximately only once a week. None of us were ever charged with murder of a co-worker.

Chapter Twenty-Four
Klaklakama Lakes Fishing Days

We would be fishing for adult coho today at Klaklakama, or Klak, Lakes. I was in charge of getting the stripping gear together, just in case any of the eggs were ready. Since I was in the incubation room, I gathered up the equipment necessary to take the milt, scale and otolith samples. Just as I was walking out the door, I remembered the measuring stick for fish lengths.

I saw that the boys were already getting the fishing net on the back of one of the trucks. Once the net was on, they loaded on the black holding bags, which would hold the fish until we were ready to strip or transport.

By eleven, Art, Lee and I headed up into the valley. We arrived at the midsection of the two Klaklakama Lakes and pulled off the logging road. Art and I walked a small part of the creek with the water only coming up to our kneecaps.

Art said, "Hey, what is that?" I walked over to where he was pointing, and saw the cutest little fish. They were only three or four inches in length but they looked like salmon. They had the red-coloured bodies and hooked little noses.

The rest of the crew showed up, and one of the boys said, "Those are landlocked kokanee. They never go to the ocean but stay in the Klak Lakes, Art."

Well, that blew me away. I always thought Kokanee was a brand of beer. The size of the kokanee in the Klak Lakes amazed me, and I could only imagine the size of the eggs that were in the female fish. They looked like large goldfish.

Now that we had all gone and seen the small fish, we went to our setting spot. The swimmers started to float down from the bridge to see if there were any coho in this part of the system. We drove for five minutes and got out of the trucks. Lee and I walked down to the embankment for two or three minutes until we hit the stream.

We heard the swimmers approaching us. Phil stood up and said, "We are going to fish here. I spotted about thirty coho and Kenny saw about the same. Go tell the rest of the crew to start moving everything down here."

As we walked back to the trucks, the moss felt like a shag carpet underfoot. I was thankful that it was nice, easy walking with hardly any blown down trees.

It was a cold October day but the sun was out. I knew that I would warm up after we had gone up and down the riverbank with all the equipment. This part of the Klaklakama was very shallow, dark in colour, with plenty of hiding places for the coho. Salal bushes, ferns and smaller branches covered both banks but were only waist-high.

Phil told the crew, "I will take this part of the net further upriver and walk back down holding it against the banks. Lee, Joe and Kenny will come with me. The rest of you guys will stay here and use the other net at this spot. Have two of you on either bank holding it firmly against the shore. The other guys will stand along the net to make sure that it does not float up and let the fish escape underneath."

I was in the middle of the stream with the water barely above my knees with a couple of workers.

We held the cork line out of the water so that the fish could not jump over and used our feet to hold the lead line down.

Phil could clearly be heard yelling, "Kenny keep the net firm to the bank. Now you and Joe start walking downstream." As they rounded the corner, we saw Phil swimming in front of the net, reaching in behind the root wads and stumps on the sides of the river to scare the coho down towards us.

The boys above us inched their way down to us and it took almost half an hour, but we were trying to get all sixty or more fish at once. From bank to bank was only five feet. When they were three feet away, another worker took the net from Kenny and he stepped over and inside our small fishing set. He put his snorkel on and proceeded to chase down the coho with Phil.

"I've got one here, Honey; it's a male," Kenny said. "He is ready to give his donation for the cause." This meant bag him because his milt was squirting easily when he was given the belly squeeze. Kenny was on his knees and said, "I have a female but she is a bit hard still. Pass me a bag and I will pass her outside the net."

Art grabbed the two bagged-fish and tied them onto one of the salal bushes in the stream.

Phil said, "Make sure the heads are facing upstream so they get enough oxygen."

"Yeah, Yeah, I know. I am not a greenhorn," Lee said.

We ended up with eighteen females and twenty-four males. We only missed our mark by maybe eight.

Four of the females were ready to be stripped and their bags had been tied with yellow flagging tape. Lee took them out one by one and gave them the head blow. He then ripped the gills out and hung them on a tree where he had put nails to bleed them out.

I was sitting on a rotten stump with my little baggie as Joe squeezed the milt out of the males for the four females. We did eight male milt bags because two bags were used to fertilize one female to ensure proper fertilization.

After we waited for twenty minutes, Phil took my spot on the stump and opened up a stripping bucket.

"Bring the first one over, Lee," he said. The four female's eggs were put into a bucket each and the milt bags placed into the stripping kit.

Phil told us to start moving the nets and the rest of the gear back up to the trucks. "Kenny and I will go and move the other fish that are not ready into a deeper area in the creek where there is a faster flow. The other truck should be arriving within half an hour with the life tank. We will break for lunch until they arrive."

As we were finishing our sandwiches, we heard Lawrence (aka Spider) tooting his horn by the logging road to let us know that he had arrived. Phil walked back up the trail to make sure the oxygen levels were set properly in the life tank. We would carry the coho one by one up the hill to the life tank.

He came back down and said, "We will divide into three groups. Kenny and I will be in the water passing a bag to the first two guys who will run it to the next two who will run it to the truck. Make sure you keep the bag as straight as possible and try not to dump too much water out as you run."

I was with Art in the second relay team and we ran up the hill and passed the heavy bag to Spider, who unzipped the bag and released it into the life tank. Each run lasted thirty seconds and we had a one-minute break in between until we spotted Joe and Lee coming with the next bag.

By the twenty-eighth time, I could feel my calves starting to sting and was glad that this was the last bag. Spider closed the lid to the life tank and started back to the hatchery. He would have to travel slowly with our precious cargo.

We were all standing around the truck, making sure that we had not left anything down by the setting spot. Phil walked around the truck to make sure everything was lashed down. I placed the eggs into a cooler box so that they would be protected and safe from dust and water.

The rest of us took a short snack break while Phil and Kenny took off their dry suits. Once they had put dry clothes on, we piled into the truck and started back on the logging road. By this time it was almost two-thirty.

I closed my eyes and thought about the kokanee fish and how fishing had gone so well. The next thing I knew, we were turning into the hatchery and it was now three-thirty.

Phil went to the incubation room and fertilized the eggs while we unloaded the trucks. Spider had already rifled the other adult coho into two round tubs before we arrived. He was disinfecting the life tank because we would be fishing for Woss chinook tomorrow at Woss Lake outlet tomorrow. This was to make sure that we did not spread any form of disease from species to species.

It was very dark by the time we were all done and heading for Alder Bay to head home on the punts. We hit the dock in Alert Bay by six. It was one of the earlier times that we finished a workday at the hatchery.

Chapter Twenty-Five
Another Day Fishing

I had been part of the hatchery crew for three or four years in a row as part of the broodstock crew and still loved being there.

We were fishing at the Woss Bridge at the Woss Lake outlet. I was given the job of driving a truck across the Woss Bridge. The truck on the bridge was used because it would have been too hard for the crew to pull the net closed by hand to capture spring and coho salmon. The crew had run the net across the lower section of the river on one side just below the bridge. There was a double block that was tied to a tree and one line ran through this double block, which was connected to the seine net.

The boys pulled this line up and out of the water so that the fish would not see it. We left the net open on one side of the river, waiting for the spring salmon and coho to run right into the net. Then we would close all escape areas and those fish would become part of our broodstock catch.

The hatchery swimmers were kicking upriver, scaring the spring salmon into our trap. Others were rifling rocks into the river to keep the fish moving upstream. Everyone started to yell and that was my cue to start towing with the truck to pull the net upriver. Once the net was pulled far enough upstream, our crew ran to the riverbank and started to pull the net tight to enclose the fish in an underwater bag where there was no escape for them.

I was fifty feet in the air above the rest of the crew because I was on the logging bridge, and I spotted a bear running along the riverbank. The bear must have smelled the previous spring salmon that we had caught and stripped of eggs. These female fish were lying on the ground and bears really like salmon roe (eggs). I yelled at the rest of the crew, "Bear, Bear!" They all turned around and saw the big black bear. Next thing I knew, there was bedlam everywhere.

We had a running line, which is at shoulder height for a normal person. It was towing the net that was stretched out across the river on one side. The diving crew in the water was laughing so hard watching the rest of the crew try to avoid the bear running along the riverbank. They felt safe in the water as the rest of the crew ran chest high and deeper to escape the bear that was only in the same area as we were because he was hungry and wanted to get some of the eggs we were trying to get.

Lee yelled at the crew on the small raft, "Come and get me, you. Don't leave me here!"

As this was going on, Tim Willie ran right into the running line, smack across his forehead, and he was all of five feet if he was lucky. He was knocked backwards by the running line and fell back on to the riverbank, as if he had been hit by a defensive end from the Super Bowl champs. I was watching this chaos from the bridge and was grateful that I was the driver of the truck today.

The bear saw all this action happening on the shoreline of the river and turned, running back into the brush. He was gone in a flash, but all I saw was the broodstock crew leaping into the river, running into the bushes, and yelling like they were being attacked by five bears. After all that helter-skelter action, Tim Willie ended up with a rope burn right across his forehead that made him look like he was wearing a deer hide skin wrapped around his forehead.

Lee denied up and down that he was yelling for the one and only raft to come back and get him. His exact words were, "Oh, come on guys, that was someone else. I would have just sucker punched that raggedly old bear and saved the rest of you chicken shits."

Bert and his brother, along with the rest of the swimmers, just looked at the rest of the crew and could not stop laughing.

I was sitting in the truck on the Woss Bridge and thought to myself, "These guys are all friends, but have no sympathy whatsoever if you cannot do the job and handle the teasing that goes with it." I was so happy that I was not Tim Willie or Cousin Lee on the beach asking those hatchery swimmers for help, because they were so busy laughing. I thought the swimmers were going to drown as they continued on with their mocking, which made it hard to keep afloat. There was so much water coming out of their snorkels as they mocked the crew running around on the riverbank.

Chapter Twenty-Six
A Day Working with Bert

It was getting late in the season and we still needed to find out where the last bunch of coho had gone. It was late in the year, and I was freezing. Hank and Bert both agreed that the coho had gone up the Davie River. They decided that Bert and Lawrence would float downriver from the midpoint of the Davie River. The Davie flows into Nimpkish River above the township of Woss.

We drove from the hatchery for an hour. Once we reached the Schoen Lake turnoff from the highway, we rode for another half an hour on a bumpy, potholed logging road. When we could drive no more, three of us walked downstream over an overgrown logging road.

Young alder saplings were beginning to reclaim the road that we traipsed over. Alder branches seemed to be reaching out and grabbing at my knitted cap. Spider webs smacked me in the face and never failed to get into my mouth as I talked with Bert. When we arrived at the bank of the Davie River, I gave flagging tape to Bert. He casually walked upstream, jumped at an overhanging bush and tied the flagging tape to the uppermost branch.

He walked back toward me and we went to the truck. Both guys changed into their swimming gear.

I zipped up both the boys' swimming outfits and then drove five miles on a logging road that headed further upstream. They both got out of the truck, carrying their snorkels and fins, and meandered down to the upper Davie River section. I tooted my horn and headed back to the pickup spot.

After two hours, I started to wonder if they were okay. The river was cold and had many boulders. I thought they would be at the pickup spot within an hour and now I was really getting worried.

Screw the bears and cougars. I got out of the nice warm truck and stood on the riverbank where the flagging tape was hung out on the bush. I finally saw a snorkel coming around the corner and was relieved. It was beginning to snow big flakes and I was wondering how they were doing with the hypothermia factor. Bert got out first and lit a cigarette. He told me that he did not see any fish. Lawrence came into sight two minutes behind Bert.

His first words were typical for Lawrence, "F'n bullshit! I knew there would be no fish in that section!"

I looked at Bert as he continued smoking and gave him the world-famous grin that pissed Lawrence off even more. I was always surprised at how the boys felt no embarrassment when they were freezing cold. I unzipped Bert's suit and he opened the back door of the truck. He grabbed his clothes and changed right in front of me as I turned my back.

I was frigging cold, too, and did not care to look because he was like a brother to me, thanks to Joe (my real brother). Both of them loved to tease me when we were out on the weekends for a few ales. I knew that he would make comments if I happened to see him change. His comments would be, "Did you like what you saw?" He knew he was muscular and would always say, "Only look, do not touch," He would make sure he said it in front of other people to embarrass me.

Lawrence was a wee bit different. He knew how to get a rise out of me, and tried to get a response from me to see if I would react to him changing in front of me.

"Have you ever seen such a physique before, probably not and never again, hey Honey," were comments that one could expect from Lawrence. The funny part was Lawrence was so cold that I had to help him out of his swimming gear. He was actually starting to shiver. I was cold too, and could only imagine what the two of them had experienced the past two and a half hours in the cold Davie River.

Both of them stripped to no clothing at all and put a new set of dry clothing on. I turned around to give them privacy. Bert laughed and told me I could turn around. I had the truck running for ten minutes so that they could jump in and warm up. Bert was warm in no time and I wondered if that had anything to do with body mass, because Bert was a lot heavier than Lawrence. I do not mean fatter, but stockier. We left that part of the Davie River and in five minutes I was starting to sweat from the heat in the truck. Bert had opened his window and was blowing cigarette smoke out the window.

Always the gentleman and considerate of others, he was trying to keep the smoke inside the vehicle to a minimum. I looked in the mirror and noticed Lawrence was still shivering in the back of the truck. When he talked to us, his teeth were actually chattering. This was probably one of the few times Lawrence was unable to carry a conversation with us because the effort to talk was too hard for him. Bert closed his smoking window and now the heat became really intense for me.

Bert looked okay but Lawrence still looked like someone had thrown him into a bucket of ice water. It took one hour to get back to the hatchery and Lawrence looked like he had been found swimming in the Arctic while I felt that I had been in a sauna for the past hour.

All I could think was, "The things we do for the job to bring up the Nimpkish River salmon stocks."

Chapter Twenty-Seven

Davie River Fishing

I was once again without a job and applied for the hatchery jobs that were recently posted. Gerry, Colleen, James, Spider and I made the short-list and were all hired. I never knew my brother's best friend, Bert Svanvik, was so tough until we went and fished the Davie River section.

Carole was hired by one of the "well thought out" government agencies that gave money to Native bands. This one was called the Aboriginal Fisheries Strategy, or A.F.S. Carole was an Aboriginal Fishery Guardian with no power. She could only observe, record and report. It was better known as OR&R. These guardians often came and helped us catch our fish to save dollars because there was never ever enough for hatchery needs.

The budget given to the hatchery was minimal, at best. The fish were dying out and disappearing. Instead of sending an ambulance full of financial help to help the salmon, Band-Aids were being doled out.

Carole and I walked, stumbled and tripped down a big hill on the Davie River, carrying PVC pipes that weighed twenty-five pounds at minimum. We were both carrying two PVC pipes each. Carole tried to keep up with me, but she turned to me and said, "Honey, I'm so sorry, but I can't do this."

PVC pipes are long, white tubes that fish were placed into to hold them in place so that they would not freak out while awaiting transportation. The fish were usually left overnight in these pipes in the river and transported the following day, after they had calmed down. The pipes had holes placed in the front and back ends so the fish could receive oxygen from the upstream river flow.

I said, "Carole, the boys will never hold it against you as long as you try." She struggled, went down that big hill and quit. I talked to her again, and she walked that long, straight stretch carrying one PVC pipe, which was good enough in the minds of the rest of the crew.

After lugging these heavy pipes down the Davie River, we then had to carry the fishing net down to the same damn area. As Carole and I carried the PVC pipes down, the boys were dismantling the fishing net into three sections. They had to carry the web, corks and lead line down the same steep hill, then put it all back together to fish in this small deep pool to catch coho. As we all caught our breath and had our lunch, I cursed the Department of Fisheries and Oceans (DFO) because they only cared about the sporties (sports fishermen).

We were chasing coho, a sport salmon, in the Davie River and were not doing anything about our own declining sockeye stocks or our chum salmon. These two salmon are what the Nimpkish people lived on. These two species supplied us our winter grocery store. We may have called the hatchery "ours," but DFO dollars dictated what species of salmon we would enhance.

We caught over fifty coho in this one area of the Davie River near some power lines. We placed them into the PVC pipes and tied a line through them to keep them in a deep area so a bear could not get at them. After we had let the fish calm down, we moved them the next day. At this point, we put them into a black bag, which had more flexibility than the white PVC pipes. The black bags were lighter but still retained the necessary water needed for the fish to breathe.

We needed to move the fish from the Davie River up the hill to vehicles that had oxygen tanks on them. They would then be transported over logging roads until we arrived at the paved highway. The drive itself would be an hour and a half to the hatchery at the mouth of the river. They would then be put into raceways until they were ready to spawn out.

From the Davie River, we hiked twenty yards on a straight stretch of moss, fallen trees and branches. Then the path took a slight incline that was at a thirty percent grade uphill. The last bit was straight uphill with no chance for a breath. That was a real killer on everyone's legs.

We had groups of two people who handled each section of this treacherous terrain. The first two had to run a flat area for twenty yards, carrying a hormonal salmon along with two gallons of river water. It was like a relay, where you laid the black bag as level as possible, then passed them on to the next two who then had to run up a slight incline. As they ran out of breath, they passed the coho and water bag to the last two, who had the hardest part.

It was almost an eighty percent incline as they ran the fish and bag uphill, trying not to lose any of the precious water. Gasping and sucking in air, they passed the bag to my co-worker, Sherry, and me. Both of us stood on the back of the truck, which had a huge live tank that had oxygen pumped into it. The boys passed us the bag, and we quickly unzipped it and let the fish out into our life tanks. The aerated oxygen kept the fish alive until we arrived at the hatchery, which was perhaps forty minutes away.

Once we were all done the marathon transport run, Gerry jumped down and did twenty sit-ups and then said, "Is that it? That was a piece of cake." We all laughed because that was how the crew handled the hard work.

The male crew had run uphill with a ten-pound coho, carrying an extra two pounds of water in a black bag without dumping any of the water. After the crew had run the fish up the hill, Sherry and I had to make sure the oxygen was just right. I climbed on the truck and looked at the oxygen level reading.

It was a bit low so I turned the valve up until it reached the appropriate area. I peeked inside and saw that there were oxygen bubbles flowing out of the tubes inside.

It took a while to make sure the adult coho were calm before we transported them back to the hatchery. The life tank that we had just loaded held thirty coho per trip.

Bert had walked up the stretch and made it look easy. When I say walk, I mean that he practically sprinted it while wearing his swim gear. He had come up to make sure the oxygen levels were set properly before Sherry and I set out for the hatchery. Bert then went back down to get the net. He came back up the hill, barely out of breath, and put part of the net on one of the trucks. He asked for something to drink and something to eat then he casually lit a smoke. I watched him with awe in my eyes and wondered how he could do such a strenuous task then light up! Once again he went back down the hill.

As we checked the oxygen levels one more time, we saw Bert walking up the hill again with a whole section of the fishing net, webs, cork and lead line. The rest of the crew were running sections of net up in groups of six and Bert carried one all by himself.

Sherry and I looked at each other in shock. We could barely get up the hill with one coho-filled black bag, never mind one-third of the net. The lead line must have weighed fifty pounds alone, not including the corks and webbing. Even as Sherry and I ran the fish back to the hatchery, the crew left still had to carry all the PVC pipes back up that hill. The pipes were then loaded on to a truck and finally the guys wearing the dry suits were able to get changed.

We had left the hatchery the day before, had done all the prep work, caught the fish and had placed them in the PVC pipes by four that afternoon. We were back out the next day at noon and were not back to the hatchery until five in the evening.

I was dedicated to bringing up our sockeye and chum stocks. It really bothered me that we were catching fifty coho and wasting so much energy to supply sport fishers who did not give back to our

communities. Sport fishers fueled their boats up in Port McNeill, stayed at fishing lodges and did all their shopping on Vancouver Island. We rarely saw them in Alert Bay spending money that would help our economy. I know they did not spend any dollars in our Native communities in any way that would benefit our people.

Chapter Twenty-Eight

Fry Reconnaissance on Kamadzina

Our crew was sent to Nimpkish Lake to do coho salmon fry capture and release. We drove from the hatchery to the Karmutzen River on the east side of what we call Kamadzina, better known as Nimpkish Lake.

We left Gwa'ni Hatchery with our traps, dip nets, wet books and pencils. It took us ten minutes on the highway until we reached the Kilpala Road turn off. I made sure to turn on my truck's headlights because we were now on active logging roads.

As usual, the logging road was dusty, with many loose pebbles, rocks and potholes throughout the drive. We arrived at Kilpala Bridge where we crossed the lake outlet into the lower Nimpkish River.

I slowed the vehicle down to make sure that there were no logging trucks coming towards us because it was only a one-lane bridge. After seeing that it was safe, we crossed the bridge and started to head up the steep logging roads until we reached Meadow Creek and Upper Kilpala River.

Charles, Clifford, Danielle, Maurice and Leeroy were my crew that day, and we pulled the truck off to the side of the road and pulled on our neoprene suits and boots.

I asked Charles if he would be in charge of the data taking and the wet book. He agreed that it would be no problem.

Clifford and Leeroy were given the task of carrying the traps and dip nets. We looked across towards Meadow Creek and saw why it was called "Meadow."

"For the love of... for us to get to the creek we have to cross almost two soccer field lengths," said Clifford.

As we were looking, a black bear ran across the meadow. This made the boys all reach back for their long walking sticks and short knives, which they carried in their packs for protection. It was funny, in a way, because sticks and small knives would be of little use if we pissed off a bear.

As we started our walk, the meadow was solid in some areas, then soft and mushy in others. In some parts, we were up to our knees in water and mud that was trying to suction off our boots. Leeroy did not hold back with the cuss words, because it felt like we had twenty-pound weights on our ankles as we tried to pull free from the mud.

Once we were back on solid ground, Charles said, "Good thing that bear was not hungry because we would have been easy pickings in that mud, hey gang." We laughed but were really glad that the bear had run off in another direction.

Once we reached the creek, we dipped the fry out, measured them, identified the species and recorded the information into the data books. This went on for an hour, with us walking in the small creek up to our waists.

The majority of the fry that we got the data from were hiding under tree stumps and small back eddies where there was not much flow. After we identified two-hundred coho, we started our trek back out the creek. It was becoming a hot August day in the valley and we all pulled our neoprene suits down to our waists when we reached the start of the large meadow.

It was noon by the time we got back to the truck and we sat down and had our lunch.

"Look at our back tire. It's almost right flat," Leeroy said. I went to the back and saw that he was right.

I decided it was best to change the tire before we got back on the logging road heading for the main highway. Clifford looked under the back of the truck and found out we had no spare. Charles told us there was no tire in the back of the truck, either. Our only option was to drive out of the valley to the highway on the low tire and hope for the best.

With my luck running as it always does, we drove for five minutes on the rough rocks and the tire blew. We had not even made it down the steep hill to cross the Kilpala logging bridge.

"Holy sheet! There is only half a tire left hanging on the rim," shouted Leeroy. Naturally, we did not believe him so we all went to the back to look and sure enough, the tire was barely hanging on.

I said, "Thank God, it did not blow out on one of the sharp corners because we might have gone over the cliff and into the lake." Our guardian angel was hanging around us on that day.

We took off our neoprene outfits and boots since we would not be in the water again, and threw all our work clothes into the truck.

"How far is it to the highway from here?" Charles asked.

"It is at least two miles to the Kilpala Bridge that we can see from here," I replied, adding, "I figure it is another five miles after that on the logging road, and then another five to ten miles on the highway until you get back to the hatchery."

The sun was beaming down us as we walked down the hill. Every half an hour we would have to run off the road as a full logging truck barreled by us with logs from the Upper Kilpala area. After choking on dust and wiping our eyes, we finally crossed the bridge before the hour was over.

We sat down for a water break and decided that two of the crew would jog the rest of the way to get help. I asked for volunteers and Clifford answered that he and Charles would walk and run to get help.

We decided that the rest of us would wait by Kilpala Bridge until they came back. We took their backpacks and gave them most of our drinking water and said good luck.

"Make lots of noise in case you run into a bear and her cubs out feeding," Maurice said.

"Ha, I am so out of shape, my loud breathing from the run should scare the bears off," Clifford replied.

By this time, it was going on two in the afternoon. We walked over to where the hatchery crew kept their net pens and sat on these, taking in the view of the mountains on the south end. The sun was becoming hotter and the next thing I heard was someone yelling, "Geronimo!"

There was this loud splash and I saw Maurice surfacing nearly five feet away from the net pen.

"Whoo hoo, this is great! You guys should jump in." He did not have to ask Leeroy and me twice. We were both in the water as soon as we could remove our socks and shoes.

After swimming for a half an hour, we climbed out and let the sun dry us off. Danielle hung her feet in the water to cool off and splashed her face every so often. Within twenty minutes, we were totally dry and jumping in again. It was now four-thirty when Danielle said she heard a truck coming towards us. We all climbed out and put our shoes on to go and meet the boys.

I asked what had taken so long and Clifford said, "Sure must be nice to be swimming. It took us almost an hour to get to the highway. We tried to ask the logging company by the highway to use the phone and they said no. I even said we were just calling the hatchery to come pick us up. That really pissed us off when we couldn't use the phone."

Charles said, "A camper passed us when we were on the logging road and wouldn't pick us up when we tried to hitchhike. I can't even remember how many logging trucks covered us in dust. We couldn't even see the road for a couple of minutes after they passed us."

"It took us another hour and a half to get to the Beaver Cove turnoff. We had our thumbs out each and every time a car passed us and no one would stop," added Clifford.

Charles laughed, and said, "A truck finally picked us up just past that turnoff and drove us the last half a mile. Both the bottoms of our feet are all raw and red now. We took our sandals off because pebbles kept getting stuck in them, so we ran barefoot."

I could not believe that they were able to laugh about this. We all thought someone would have given them a ride. We all climbed into their truck and went back to change the tire.

It was almost six o'clock by the time we were heading back to the hatchery, and the two boys were in a better mood. That weekend, I invited the whole crew to my house and cooked a dinner for them, but it was mainly for Clifford and Charles, who had run so many miles for us.

Chapter Twenty-Nine

Hatchery Work in the Nineties

I had just completed a job and knew that the hatchery was hiring for the yearly broodstock in early October. I applied and was told that it was one of the new BC government make-work projects. I was one of the lucky candidates chosen because of my previous hatchery experience.

I was told that the salary would be almost a one-third top-up of what I was presently getting on my Unemployment Insurance (better known as UI) cheque. Imagine my surprise when I opened my paycheque envelope. I was getting topped up thirty-seven cents an hour.

I said to Hank and Bert that this was totally unfair because of my experience, but because my UI was so high, that was all the money the program would top up. Talk about being pissed off, because there was no other way to describe that feeling.

All I could think of was what our MLAs and the people who sit in our House of Parliament were receiving after retirement. Even when they were wrongfully dismissed, they still received a generous payout.

The real killer was that if I did not go to work at the hatchery for these wages, the Unemployment Insurance Office would cut my

benefits off. It would be seen as not going to work in a position that was willing to employ me. The opinion in the UI office was that I was not trying to find work or was unwilling to work! It was a "Catch 22." Screwed if you do and screwed if you don't. I went to work at the hatchery for the four months because I loved what we did and there was no way I was going to let the government keep my UI dollars.

I had fun teasing Bert and Hank, saying that the Chinese workers were paid more for building the railway across Canada than I was getting each and every day. Because of this, and all the joking about how I came so cheap, I know that Hank and Bert found a way to keep me on for the weekend shifts at the hatchery after we finished fishing for the broodstock. My UI claim was still going and they managed to keep me under the limit of getting pay deductions for working too many hours. I did make a few bucks working Friday to Monday. Weekend wages were not allowed to be deducted under the UI stringent rules.

I did the weekend thing for three or four weeks at the Gwa'ni Hatchery. The next weekend, my friend, Shannon, came across on the last ferry from Alert Bay to stay with me at the hatchery. I went to put a pot of water on to boil to make Indian pasta (Kraft Dinner) when I realized that the water flow was low. The tap water was barely a trickle! I knew that if the water flow was low, the salmon eggs, fry and any other living objects would die due to lack of oxygen.

There was a huge aeration tower five hundred metres away from the living quarters. The tower creates higher oxygen levels by going up a pipe then back down, pouring into a huge cement holding pool. The building was two storeys high that I had to walk up and check on. I said, "Shannon, I am going to check on the water flow at the aeration tower. You don't have to come."

She said she'd come with me. I kind of laughed under my breath because I knew she was scared to be by herself.

Our Elders say that some of us have premonitions and I swear Shannon had one that night.

It was a full moon, four days before Christmas, and I was thinking what a beautiful night to be over here babysitting the fish.

I started up the hundred-odd metal stairs that led to the top of the aeration tower. After reaching the top, I started to walk around the eight high-towers on the aeration tower to make sure that water was flowing. My flashlight was pointing at the towers. Someone had not closed one of the steel grids where we took water temperature, oxygen levels and other important data. The open hole was the size of an open manhole on any city street.

As I backed up, I dropped four feet into the tower! My last thoughts were, "Shannon and I were just laughing today about something like this happening!"

We both said that if anybody fell in, they wouldn't have a chance in hell. You would fall in and get sucked into the big round hole where all the water flows down and out into the Nimpkish River. You would be carried down along the hole much like the water that is flushed out of a pipe in an unplugged drain. Once you reached the bottom where the elbow was, you would break your neck and gush out through the drainage system like a Raggedy Anne doll towards the river.

Ha ha—it sure wasn't funny as I dropped down and into the aeration tower, which was the size of a small swimming pool. Everything Shannon and I had said ran through my mind. Shannon was screaming my name as she ran over to try to grab me.

I did not even feel the cold water. I kicked my boots off and tried to fling my jacket off, but it was zippered up because of the cold weather. I kicked and paddled upwards as hard as I could. I felt the big hole sucking at my feet, trying to pull me down and into the Nimpkish River. I could hear the gurgling sound of the water hitting the sides of the hole as it gushed downwards, and I knew that I would not have a chance if I let the flow pull me down.

I looked upwards and could make out Shannon's shadowy, distorted outline above me. It looked so far away and I wondered if I was still wearing my glasses.

My jacket felt so heavy and it did not seem like I was making any headway towards the lights above as I swam for my life. I came up gasping for air and saw that full moon. My thoughts were, "I can't die tonight. Christmas is in a few days. How can I die on such a beautiful night?" I looked down and saw my flashlight turn over and over, a beam of light, then dark then light, over and over again.

The flashlight disappeared and I knew that it had gone in and down the big black hole. That only made me kick and paddle harder to stay above water.

Shannon was lying on her stomach, hands outreached, waiting for me to surface, and she grabbed me by my winter jacket collar.

I yelled, "Don't let me go!" Adrenaline and fear were racing throughout my body.

She said, "I won't let you go," and then I realized that she could only hang on for so long.

I said, "Let me hang on to the bars here and go call for help."

She said again, "I won't let you go." Then she let me go and I thought, "What the hell? Why did she let me go now?" I thought Shannon had seen one too many movies where you almost rescue someone and then they fall out of their jacket. That was why she had let me go. She reached down and grabbed me by the seat of my pants and held on for dear life—my life and my pants. I told her to go and get rope so she could tie it around me for a lifeline.

Shannon looked around and realized that she couldn't even yell for help. There was absolutely no one else around. Then she looked around the hatchery grounds wondering where to find a rope. She did not know the hatchery or where we stored any equipment. That is why she could not let me go. She asked God to give her the strength in her hands to hold on to the back of my pants, and to give her the strength to help lift me out of the water. Shannon always thought that she had weak hands and believed that she would need the spirit of angels or her ancestors to help her save me.

She refused to get rope and gave one great pull.

That pull got one of my legs four feet out of the water and on to the metal serrated platform, but I was weakening and was having a hard time holding on. Shannon was in panic mode and kept trying to pull me up, and I realized then that I was safe. I told her to calm down, get her breath back and rest a bit. She listened, and then gave another pull and got me out. When I finally stood up on the metal grids, I discovered I had my glasses still hanging on to the collar of my jacket by one arm.

A weird thought ran through my head. Did I really see that flashlight falling into the big suction hole? Did I see the moon? Did I see lights above me or was that my imagination playing havoc with me? Was that Shannon I saw looking down at me as I started to sink? I happen to have very bad eyesight without my glasses, and my glasses being lost was one of many thoughts in my head when I was finally out of the water. I was thinking such dumb thoughts when I should have been thanking our Creator or God that I was alive.

We had gone to the aeration tower near six o'clock in the evening, and I was in the water a maximum of fifteen minutes but it felt like an hour. Shannon said she walked me down the stairs and took me into the hatchery building, then threw me into the shower to warm up. I was shivering but I think it was from shock more than the cold of the water in the aeration tower.

I am telling this from Shannon's memory. I was in shock, barely believing that I had not broken my neck and ended up as crab bait at the mouth of the Nimpkish River.

I phoned Bert in Alert Bay and told him about the low water flow but I do not think I was making sense. I needed a drink and asked Shannon to drive me to Port McNeill to get some beer. We were not allowed to drink on the job but at the time I didn't care. I felt that this time was one of the exceptions to this rule. We like to say in the Bay that this was, "Deserve Time."

Shannon drove twenty kilometers an hour into Port McNeill and the speed limit is eighty.

She was now in shock and I think I could have driven us into town, but she would not let me.

I must have told Bert about my near-death experience because when we came back from town he was standing in front of the hatchery, smoke in hand as usual, waiting for us. I threw my drink out the window and tried to act nonchalant.

I was still in shock and Bert asked me if I wanted to go home. He said that he would take over my night shift. I said no but he still stayed for an hour to make sure that I could carry out my duties. Bert came from Alert Bay on the hatchery punt that could travel upriver in low water. It was dark and it would have been hard to see the rocks in the river, yet he still came to check up on me. He was that type of person who would make sure I was okay. I know that he was worried about the fish and eggs too, but it was me he came to see and I was the priority, not the job. I had the best boss, who put me before anything.

He came over on the punt before Christmas and took time away from his family to make sure I was okay. The boat ride is forty minutes one way, and he stayed for that hour, then went back on the boat. It showed me his leadership and caring nature.

When I got home after my weekend shift, my cousin Lee called, and asked, "Did you really fall into the tower? Jesus you are sure lucky. I was telling our family about how high it is and how deep the water is. I cannot believe you did not die. I am sure glad that Shannon was there with you." Many of the present-day hatchery workers and past workers called me to say they were glad that I was okay.

Hatchery workers may fight on the job but all understood the danger that could befall one of us at any given moment. It was because of this knowledge that we stuck together in times of trouble. Each and every one of us knew that the next time, another one of us could fall into trouble.

Chapter Thirty
Chum Fishing and Transfer

The hatchery crew that had fished commercially went out on a seine boat to catch the chum broodstock on a cold November morning. The rest of the gang caught the crew boat from Alert Bay to Alder Bay.

As the seine boat went fishing for the day, the rest of us were getting the raceways ready for the adult salmon. Sherry and I were put into the raceways to scrub the algae off the walls, and then we gave them a thorough rinse. Sherry complained about how cold it was that day. But after an hour of climbing in the raceways, and scrubbing the cement sides and bottom, both of us were sweating like it was a hot summer day.

We then closed off the ends of the raceways with the blocks and went to the head of the raceways to turn on the water. I held a ten-gallon bucket under the gushing water and Sherry timed how many seconds it took to fill the bucket. The water flow had to be set just right to create enough oxygen for the salmon that would be placed into the raceways. This was a time consuming process and very hard on the person holding the bucket so we rotated often as we set the flows for the raceways.

The next job was to go and get the oxygen cylinders filled in Port McNeill.

Sherry went to do this while Gerald, Kenny and Lawrence loaded the life tanks on to the transportation trucks. Gerald climbed into one life tank with a deck brush and started giving it a good cleaning while Kenny and Lawrence did the same in the larger tank.

"Okay gang, let's give it a good rinse then take a break until Sherry gets back with the oxygen tanks," said Lawrence. We all ran inside to warm up after we finished, because once you stopped moving, the cold was immediately felt by all.

After a quick coffee or tea, Sherry pulled in with the oxygen tanks and we went back out while she went in and had her coffee break. Lawrence and Kenny went to move the oxygen cylinders to the back of the trucks. Gerald and I went to get the tubes and oxygen bars that would hook up to the cylinders and go into the life tanks.

As I was walking towards the main office, Gerald yelled, "Get off the truck! It's going to blow." All I could think was, "What the hell is going on now?"

Gerald had accidentally turned on the valve and the oxygen was shooting out of the head of the cylinder. I have never seen anyone leap off the truck so fast in my life. Lawrence casually climbed back on the truck and turned it off. Looking at Gerald with a smirk on his face, he burst out laughing.

Gerald started to laugh and said, "Gee, I really thought it was going to blow up." We teased Gerald for the rest of the day about the fear in his face. He kept saying, "Yeah, but you never know." He was able to laugh along with the rest of us later on as he realized how he must have looked.

Bert came out and told us that the boys had caught about eight hundred chum so we would be having a busy time the next day. We went home that night on the crew boat and we saw the seine boat towing the net pen slowly towards Alder Bay. The guys on the seine boat were not done until eight-thirty that evening.

We were on the breakwater in the bay bright and early. The seine crew stayed in Alder Bay and used the crew boat to tow the net pen closer to the boat launch area.

Sherry, Lawrence, Kenny, Gerald and I went to the hatchery with Hank and Bert.

Hank told the boys to get the chum slides ready for the Final Raceways One and Two. This meant that they had to lash two green tubes at the ends of both raceways. When we were ready to transport the chum, one raceway would be for the males and the other for females.

Bert told Sherry and me to fill the life tanks to the maximum and set the oxygen levels, then head back to Alder Bay to see how the boys were doing. Sherry and I took the smaller truck with the life tank that could hold twenty to thirty fish, depending on their size. Lawrence and Gerald would come with the larger tank that could hold over one hundred fish.

When we drove down to the boat launch, we could see that the boys were ready for us. They had moved the net pen as close as possible to the shore and had tied up part of the net so that there was a bag for us to dip the salmon out of.

Sherry backed the truck up while Phil guided her, saying, "A bit more, a bit more, whoa!" Two guys were dipping out two fish at a time and passing the dip net to two more people on the beach, who then ran it up to Sherry and me. We were standing on the sides of the truck ready to grab the fish. The fish were fighting and wiggling every which way, due to the stress of transporting and lack of oxygen. Sherry yelled, "Hurry and get the fish in."

"Come on girls, you are slowing us down," Bishop yelled, as he stood on the outer edge of the net pen with cigarette in hand. Both Sherry and I were drenched from the squirming fish because they never failed to splash with their tails as soon as they hit the life tank and the life-giving oxygen.

I looked at Bishop and said, "You come over here and we will go where you are and have a cigarette." He just laughed, then proceeded to take his turn with the dip net.

After we had a full load, Phil checked the oxygen level in the life tank and said we were good to go.

The ride from Alder Bay took twenty minutes with a full load on the back of the truck, and we went slow when we hit any bumps.

As we were leaving, we passed Lawrence and Gerald going for the next load of fish. When we turned into the hatchery, Kenny and Chubby came to meet us.

Chubby asked Kenny to do the first few fish and he would relieve him. So Sherry and I backed the truck up to the chum slide that was level with our life tank on the truck. We opened the top of the tank then grabbed our wet book to record data.

Kenny climbed into the life tank and immediately was splashed by excited fish. He grabbed one by the tail and took a good look at it. He yelled, "Male," then threw it into Raceway One.

Sherry was recording all the males thrown into Raceway One and I recorded all the females sliding into Raceway Two. For the next twenty minutes, Kenny was yelling, "Male, female, male, male, female," and so on, until our tank was empty. When Kenny was getting to the last few fish, he drained most of the water so that he could catch them, because even in that enclosed area, the fish move very fast.

Kenny said, "Hey Chub, I thought you were going to relieve me. Oh well, you can get the next batch that comes in. That one will have a hundred or so, not just thirty fish."

Sherry and I went to the aeration tower to refill our life tank, and started our journey back to Alder Bay. We must have made ten trips each because by the end of the day, we had placed 450 females and 861 males into the two raceways.

It was almost nine o'clock by the time we were finished and we were freezing in the winter night. We had to empty out the net pen at Alder Bay because the crew was going fishing again to get more chum out in the ocean the next day.

When we left Alder Bay on the crew boats, we lay our heads down on the tables or leaned them back against the wall.

Diane Jacobson

It was only a fifteen-minute ride but it felt good to lie back and close our eyes at the end of what would be the first of many hard days transporting chum.

Chapter Thirty-One
A Feel Good Day

The boys were on the second day of fishing on the seine boat, and the remaining crew headed to Alder Bay once again on the smaller boats. We piled into the trucks and began our day by driving to the Gwa'ni Hatchery.

"Hey Sher, you guys are going to have a feel good day," Bert said. I knew what that meant, but Sherry shot him a puzzled look.

We arrived at the hatchery and put our lunch gear into our lockers, then headed to our neoprene suits. The boys went to get the dividers to place into the raceways. Lawrence was directing staff—three of them need to go by the water inflow and scare the fish to the end of Raceway One.

Gerry, Kenny and I jumped in and scared the fish further down the raceway. They passed us a metal divider to keep the fish from trying to swim back past us. We slowly walked to the other end of the raceway, carrying the heavy metal divider.

Lawrence and Ben had another divider ready to go. Once we scared the fish one-third of the way down, they dropped the divider in, trapping the fish in a tight area.

We proceeded to Raceway Two and did the same thing.

The boys then went and placed another divider halfway down the raceways so we now had three areas in each raceway to put fish in.

Lawrence told me, "You, Sherry and Kenny go to one raceway. You girls get in and dip net out the fish to Gerald. He will check the males to see if the milt is starting to shoot out yet. If nothing comes out, Gerald will run them to the end in the dip net. If there is milt coming out, rifle them into the next section."

Lawrence went with Chubby and Ben to check on the females. All the ones that were ready or close to being ready to be stripped would be rifled to the next section. If the eggs were still hard and not moving, they would run them to the end with the dip net. That way, they would have them separated into the readies, the A's (which means close to being stripped of their eggs in hatchery lingo), or a-ways to go yet.

Sherry now knew what Bert meant by having a 'feel good day.' We had almost a thousand fish to sort on this day.

Sherry and I jumped into the raceway and started to chase the salmon with two dip nets. I snared one right away and passed it to Gerald, who gave the belly a quick squeeze. This one was ready so he dropped it behind the divider right beside us. Sherry passed the next one up and this fish was not ready so Gerald ran to the head of the raceway. As Gerald came back to us he mentioned not having to go to soccer practice that night because of the many wind sprints he did running with the ten-pound chums.

As the day ran on, we traded places so that different people would get a feel for seeing how one could tell if the milt or eggs were ready. This feel good day lasted until quitting time. Sherry mockingly said, "Feel good day, yeah right! That was hard work." The next few days were going to be much the same as the last two: plenty of muscle power needed.

Chapter Thirty-Two
Ever-Changing River

Sherry and I were the drivers for this week's fish count swimmers. It was a nice summer job that did not include any manual labour, and we were really looking forward to this easy job.

Our two swimmers were Gerald and Widu. The young men would suit up at the Woss Lake outlet and swim to the Woss/Nimpkish River junctions, counting all species of salmon they spotted. This stretch of the river is five miles long.

After we dropped them off, we would have free time for a good hour and a half. We went back to Woss Lake and sat on the dock in shorts and tank tops to soak up some sunshine. After an hour or so, I said to Sherry, "That went by too fast. It's time to head back down to the highway and get to the river junction to get the fish count numbers."

"You're right, time went by too fast. I am so relaxed from just laying on the dock and enjoying the rays," said Sherry.

After a bouncy ride on the logging roads from the lake, we reached the highway and drove down to the BC Hydro access road, CB 9/11. "Here we go again," Sherry said. The access road had many more potholes and bumps than a Canfor logging road.

We arrived at the river junction and sat on large boulders, waiting for the boys to come around the corner. Within ten minutes, we spotted a shiny reflection as one of the guys lifted his head and the sun bounced off the glass on his wet snorkel mask. Within five minutes, we could make out the snorkels and the odd splash from their flippers as they came closer to where we were.

They pulled up onto the beach area and gave us their numbers. Gerald said that he saw two hundred sockeye, ten chinook and forty coho with five humpies. Widu was on the left side of the river and saw three hundred and fifty sockeye, five chinook, and ten coho, and no humpies at all.

Sherry recorded the data into the book and read it back to them to make sure that it was recorded right. Before they took off to the next reporting area, the boys grabbed a sandwich and something to drink from the lunch bags that we carried in the truck for them.

We went and waited at a place our crew called "Steep Hill." Gerald and Widu only saw ten chinook in this stretch of the river.

Both men were griping about having to carry on from Steep Hill and on through the canyon section. Gerald said, "It can be really dry and you pretty well have to walk a lot of this area. It really sucks. But it can be really hairy at times, too. You never know what to expect."

I asked, "Well, how long do you think it will take?" Both of them figured two hours. Sherry and I looked at each other with the same thought in mind. It was only fifteen minutes back to the lake and we were going to make the most of our tanning time.

"See you guys in two hours then," I said, as we waved bye to them and headed back to the lake. After tanning at the lake for an hour and a half, we headed back on the logging road that was on the opposite side of the Nimpkish River and away from the highway. It took us half an hour to get there and were we surprised to see them sitting by a logging bridge by the pickup spot. Their suits were pulled down to the waist and they looked awfully hot. They were covered in dust because there was active logging going on in this area.

Sherry said, "Holy crap! Their hair is already dry and so are their t-shirts. They must have been waiting for quite a while."

Sure enough, Gerald asked, "What took you guys so long? We've been waiting at least forty-five minutes. I'm hungry and I want to get out of these wet clothes."

Then I realized it had rained all weekend and the side streams and channels must have been pouring into the main Nimpkish River. I stupidly asked if they had seen any fish. If looks could kill, I would not be telling this story.

"We felt like we were on a roller coaster going through some of the stretches," Widu said. "That S.O.B. is really running. I will probably be able to see every rock I bounced over by the amount of bruises on my body."

"I knew that swimming this part was not a good idea," Gerald said. "All we saw were bubbles from the river slapping against the rocks. Crap, we were so busy trying to protect our heads with our hands and watching for the next rock to appear in our way, we did not even look into the water for fish."

I knew Gerald did not like dangerous situations and for him to have completed this section of the river was a major accomplishment on his part. Honestly, none of us likes to be literally put between a rock and a hard place but today these boys were.

From that time on, no one swam this part of the river unless we did a reconnaissance at the beginning, the middle and end sections of the river. Our people call the middle section of the Nimpkish River Tla-anis (also spelled Kla-anch), and it means rough terrain. The four of us found this to be an appropriate name on this particular day. There are still places around the town of Woss called Kla-anch.

Chapter Thirty-Three
Thirty Years of Broodstock

Broodstock is the word we use to describe the male and female Chinook, dog salmon and coho salmon we catch. These salmon carry the eggs or "brood" for our "stock" that we incubate at the Gwa'ni Hatchery to get a better survival rate than in the wild.

We left Alert Bay on a hatchery punt every morning at seven and headed across to Alder Bay. The proper name for Alder Bay in Kwak'wala is Na̱xa'gadi, which means "having brant geese."

The ride took fifteen minutes, and the crew rode in two hatchery vehicles. There was usually a half-hour meeting with Bert, who was the lead hand when it came to where and when we would fish. Henry (Hank) was the manager and had input into all decisions about where we would fish, and was also at these meetings.

Once the meeting was over, I headed over to the incubation room because it was my job to make sure that I had the equipment needed to take salmon scale samples, in order to determine each individual fish's age. I also needed to grab the disinfectant for the small surgical knives, the baggies and the felt pens and pencils for use later. These tools would be used to take out partial pieces of the kidney of each fish to make sure that they did not have kidney infections, and record all the data.

If a fish was determined to have kidney disease, we had to immediately pull the eggs that came from that fish and get rid of them so that this disease would not spread to future salmon stocks. Each crewmember had a job to do and when we were all ready, we headed upriver to the Woss River (Wa's, which means "river on ground" in Kwak'wala).

Phil, Sherry Lynn and I were placed in charge of one vehicle. The crew was told to put the seine net and a rubber raft on the back of the hatchery truck. The net, which consists of webbing, corks and a lead line, was carefully placed on to the back of the truck, then lashed down. One of the crewmembers then placed the rubber raft on top of the net. This person then secured it on to the truck, or so we thought.

Our crew left the hatchery and began the long drive up to the Nimpkish Valley somewhere near eleven in the morning. As we were rounding a corner on the highway halfway up Nimpkish Lake, Phil yelled out loud, "Oh, Shit!" I looked out the back window and saw that someone had tied the raft to the seine net and the backdraft from the highway conditions had pulled the raft up and over the back-end of the truck.

My first thought was "Oh my God!" It only became worse when I saw that the raft was tied to the whole goddamn net. The next thing I knew, the whole net, including web line, corks and lead line, was running off the back of the truck. We slammed on the brakes when we realized that we were making a round set with our net on one side of the Island Highway.

Phil and I jumped out of the truck. We never moved so quickly as when we leapt up and into the back of the truck. Sherry put the truck into reverse as Phil and I grabbed a part of the net.

The regular bus that runs from Port Hardy to Campbell River rounded the last corner and was heading right for us. I never saw Phil and myself scamper so fast as Sherry backed up while we were pulling the net and raft back into the truck.

Fishermen in our territory call this "back hauling" when you are in a big jam, as we sure the hell were! All we were thinking was, "Please, let us get the mess back into the truck before the rest of the crew catches up to us." No such luck, because my cousin, Bishop, came barreling by in the next vehicle, not too far behind the bus.

Speaking on the hand-held radio, Bishop said, "Honey, you guys almost filled your brailer net on that last set! I have heard about desperate sets, but I never thought I would see the day that you would make a set on a bunch of people on a bus." Bishop loved to razz us and I knew that we would get an earful all day about the highway set. All I could say to myself was "Oh well, another day on the job." But deep down I was wondering, "Why am I always with the bunch that screws up? Is it me, or is there a big black cloud that follows me around at the hatchery?"

I came to the conclusion that we all have faults and whenever there is a major screw-up with the crew, I just happen to be there. I have had to learn to deal with this and enjoy each and every moment because where else would I have the pleasure to work with such a great crew.

Chapter Thirty-Four
Another Decade and Another Dollar

Sherry and I were on the crew again for the broodstock capture. We chuckled about surviving the big computer crash of 2000, better known as the Y2K bug. We were unable to get the dog salmon needed with the seine boat in Johnstone Strait and Cormorant Channel, so we would have to fish for them in the river.

The chum had already gone into the river system. We knew that the dog salmon spawned out in the lower Nimpkish River before Nimpkish Lake, so that is where we would be fishing for our annual stocks. It came down to our crew having to fish in the river right in front of the hatchery.

As usual, the men thought that Sherry and I might get hurt fishing in the river so we were delegated to the sidelines as they worked their butts off. They felt that we were too fragile to work with them. We stood there feeling useless for an hour until I said to Sherry, "Screw this! There are fish ready in the holding raceways. Let's go and check for the ones that are ready to be stripped. If the females feel soft enough, let's go and grab the males and get the milt. We can at least be useful, not just damn observers."

Sherry looked up to me as a teacher and said, "Sure, the day is dragging because we are doing f-all."

We headed to the raceways and found enough female chum salmon to knock out (a nice word for kill) and strip. Then we leapt into the raceways and grabbed all the males that had the gleam in their eyes, which meant that they would spit out plenty of milt for us to fertilize the eggs. I had my Zip-loc bag ready and Sherry climbed out of the raceway with a large male. She bent her knee over the chair I was sitting on and squeezed the male chum's stomach for all it was worth.

"Get ready," she said, "because this one is a real comer! Get more bags because he is good for at least three more bags."

I looked at her and started laughing because she was really enjoying herself. We felt good because we were doing something and no longer observing. Once we took the milt, we eyeballed the females that were potentially ready to be stripped of their eggs.

It was my turn to jump into the raceway and I was in the water up to my waist. After catching one of the quick swimming salmon, I passed the fish to Sherry. Sherry checked to see that each female fish's stomach was soft and ready to be stripped of its eggs. When a fish was ready to be stripped, Sherry grabbed it by its tail and gave it the deadly death knock to the head. She then pulled the gills out and hung the fish body by its tail so that the blood would drain out. After the females had bled out, we set up for stripping them of their eggs.

I sat down while Sherry grabbed the female by the gills and turned it upside down so the eggs would pour out. I quickly pulled the knife up from the fish anus and up her gut. The eggs poured out nice and easy into the bucket that had a plastic bag placed into it. We did two more females in succession and then sealed the bucket lid. We moved on to the next bucket and continued on until we had enough to fertilize with the milt that we already had.

Hank, our boss, came out of his office and saw what we were doing. I thought, "Oh shit, I didn't ask him first if we could strip the first batch of chum salmon." He casually walked over and gave us that Hank smile, which I knew meant he was impressed with us for taking the ball and running with it.

Sherry and I had knocked out thirty-six chum female salmon and taken their eggs. Next, we got back into the raceways and took the milt from the males to fertilize more eggs.

By the time the boys had finished the second fishing set on the Nimpkish River, we had taken the eggs and the milt, went to the fertilization room, and did all the preparation to put the new future salmon into the rearing trays. Bert walked by after his group had finished fishing in the river and saw what we were doing. He gave us his big grin and I just knew that he was pretty impressed with us.

He still had his dry suit on and he stood behind me as Sherry squeezed the milt from another chum into the Zip-loc bag. He lit one of his cigarettes and started chatting with us. I felt proud that Bert and Hank were happy with us for taking the bull by the horns. Sherry and I had proven that we could take the eggs and milt, fertilize and count the eggs, and put them into the ten-minute disinfectant bath. The day ended and Sherry and I felt really good about what we had done. Another day at the hatchery and Sherry did it again! She made my day, and Bert's, as well.

We had decided on our own to be productive on the job. This was one of my better days working with the hatchery crew (or not working with them) and will always be one of my best memories.

The boys were fishing in front of the hatchery in the river again. Since we had proven ourselves the day before, they asked Sherry to talk on the walkie-talkie, which was a fairly important job. You had to let the other person using the other walkie-talkie know when to do certain key things to make our fishing set successful.

The crew let the net out on the upriver side and the natural river flow pulled the boat and net downstream. Lee was waiting further downstream and he grabbed the boat and pulled it ashore. He then ran the line connected to the net to Clifford, who was driving the hatchery truck, and attached the running line to the trailer hitch on the back of the vehicle.

The distance between Sherry and Clifford was a soccer field length, or well over one hundred yards. Sherry was at the top end talking to him on the radio, telling him when to go slow, go fast or stop. I was standing beside her and she was calmly telling him what to do so that our hatchery swimmers inside the fishing net did not get caught up in the webbing underwater.

Sherry said, "Whoa, slow down, go back and try again. You've almost got it right. Yes, yes, you've almost hit the right spot, back up and try again. Ohh, go again, back up and push again, yes, you've hit the right spot! Cliff, slow down and you've almost got it in the right spot. Slow down and then go fast. YES, now you've hit the right spot."

This conversation continued for many minutes and Bert, who was working in the office on paper work, sauntered out to have a smoke. He walked towards Sherry and me.

"Who is that talking on the radio?" Bert asked.

"That's me, Bert, what's wrong?" Sherry asked.

Bert looked at her, smiled cheekily and said, "You do know that you guys are on channel seventy-eight."

That was the channel for the whole fishing fleet, which every boat could hear in and around Johnstone Strait. I thought back on Sherry's end of the conversation on the radio, and laughed with Bert because it sounded like a porno commercial.

We came home and our older cousin, Eva, called us because she had recognized Sherry's voice. We were at Sherry's house and Eva said, "Where do you girls work? I want to put my name in for a job because I am not getting enough action. You girls get paid for the stuff that I listened to today. I was turned on and I can only imagine what the fishing fleet was thinking listening to you." We had a good laugh at the things we say but do not realize how it sounds to others.

Chapter Thirty-Five
The Hatchery Crew as it Evolved

Over the years, I went from hating being on a small boat, to hating being on the ferry, to hating living in a camper, to hating living at the hatchery and back to hating travelling on a small boat over and over. However, I always loved working at the hatchery itself, and have recommended it to anyone who doesn't know what they want to do, because this type of job makes you a stronger all-around person.

On one of our early morning starts, Sherry, Bert, Lee and I were on the crew boat going to Alder Bay. There were more of us but I do not remember who they were because my mind blocked it out and still does to this day. Call it shock, but I still cannot remember all the details.

It was like the "Perfect Storm." It was one of those days where there was a 'Nimpkish wind' that blows out of our Valley. A Nimpkish wind hits you full force in the face because it hits Alert Bay smack on as it funnels down from the West Coast down the Nimpkish Valley. We were all piled into the crew boat from the Indian breakwater and were going to head across to Alder Bay, which is normally a ten-minute boat ride, but not that day.

We left the breakwater and Bert was calm as usual, but then the waves started to hit us.

We were barely ten feet outside the breakwater and one huge swell came up. Bert pulled up on the throttle and tried to ride it out. I had never seen Bert sweat bullets, but that morning he did. One has to give him credit, though, because he said very calmly "Grab a life jacket. This does not look good."

He was so composed looking that I was not worried until I saw him pulling back hard on the throttle and staring up at that huge wave. I looked up and did not even have time to put a life jacket on. We went up and down so fast. The crest of the first wave hit us and washed all around, then up behind us.

It was like being on a roller coaster, but in slow motion, where you could see every bit of that huge wave as it rode us upwards then downwards in a matter of milliseconds. It happened so fast but at the same time it felt like watching a movie in slow motion. I looked up to see another wave crashing down on us, and we still had not recovered from the one before.

I started praying and thought, "How can I drown this close to our reserve?" I still do not know how we came out of the second swell when it looked like we would never come back up from that first big wave. I said, "Bert, let's turn around and go back to the breakwater." But as I have now learned, hatchery workers will always go to work, no matter how scary it may seem. We were taught to be brave and carry on, because the job was the main thing, even though it may have scared the pants off of our families to see us crossing the water in all types of weather.

Weathered fishermen have seen us going across in punts with no life jackets and said to their wives, "That crew is nuts!" I said silent prayers and held Sherry's hand as we crossed from Alert Bay to Alder Bay. We joked the whole way across to relieve the tension.

Once Bert lit a cigarette, we knew that we were past the worst part of the waves. If Bert had been worried or under pressure, I know that he would have had both hands on the wheel. I was never so happy to see him light that cigarette.

Diane Jacobson

We docked, and we tipped from side to side as we walked up the wharf because it was so rough, but we all went to work. I remember Bert telling us that was a piece of cake. Meanwhile, I was so happy to have a locker at the hatchery because I knew that my pants were wet, and it wasn't just from the waves.

Chapter Thirty-six

Reflecting on my Years in the Nimpkish Valley

After working on one of my UI weekends at the hatchery, I came home and ran into the band manager, Lawrence (a.k.a. Lou). Lou told me that there was a treaty trainee position coming up. He had heard that I like to read lots and this would be right up my alley.

I said to myself, "It has to be better than working at the hatchery on a stale government top-up that pays very little." I put my name in and ended up with the job. To this day, I think the world of Lou for recommending it to me.

Looking back at my two decades of working in the valley, I have finally found out why I have always loved the valley. It has been hard, treacherous, humorous, harsh and many other words that cannot begin to describe why I always went back over and over. I feel now that I was in touch with my Elders, ancestors, and my history but did not even know it. I was lucky enough to work with all types of family whom I now know are related to past chiefs that walked the same rivers, lakes, mountains and side streams as we do now. I have been so lucky to walk, float, raft or to be on the same land and waters as they had been in the past.

Bert must have felt just like I did. He has a brother who is a chief who has now claimed his hereditary position.

Bert and I did not know why we liked working in the valley so much, until we both grew up mentally and physically. We were eventually able to understand why we always loved the valley. Looking back, I cannot even begin to count the times that I passed pictographs while I was working on the lakes and never once saw them. I did not know what a culturally modified tree was. I did not know how to strip a tree. I never learned how to weave cedar bark.

When I first started working in the valley, I didn't care about culture—never realizing that I was being taught culture by our Elders who have passed on from this world. They were all around us each and every day that I worked in the valley.

A few years ago, when the first bunch of youth walked the Grease Trail, and came back with crazy stories, I thought they were full of bullshit. I did not believe that my cousins Wah and Kodi saw a ghost canoe at Woss Lake. They said they had seen our Elders when they were paddling a canoe on Woss Lake.

The canoe the boys had seen was in perfect synchronization with theirs, with little or no splash evident as the paddles hit the water. This ghost canoe paddled in front of them, and no matter how hard they tried, our cousins said they could not catch the other canoe.

Then I went to Woss for a camping trip. We came home and downloaded our digital pictures. In one photo, we are sitting around our campfire and guess what? The flames and smoke from the fire are going one way and ghostly smoke formed Elders all around us where there should have been no smoke at all, but there it was. There are gray and black figures in the background of every photo. One of the smoke-like figures is putting a ring around my youngest sister, Gin, who has always participated in our Native culture. There are ghostly female figures in the bush all around us along with what looks like a Killer Whale mask dancer. One of the main dancers of a highly ranked dance called the Animal Kingdom was clearly showing in the pictures.

My sister, Gin, is the most spiritual of my immediate family, and believes in Native culture, and I really do believe that the Elders gave their blessing when one of them put a smoke ring around her

neck. She should be proud of who she is. Our Elders believed in adoption. If a sister could not have a child, then a family member gave the childless person one of theirs. Even though my parents had children, my cousin gave us the best gift ever: a sister.

For a person with a vivid imagination, I did not know how rich my history in the Nimpkish Valley was. When I saw the ghostly figures all around the campfire in Woss Lake, I knew then that there is an afterlife. I now know that Granny A<u>x</u>u, Dad and all my deceased relatives will be waiting for me along with all the rest of my ancestors. I am no longer afraid of death, as I was when I thought I was going to drown, not once but a few times. I never used to be cultural—never thought I would be—but the valley has shown me otherwise.

Since my days working in the valley with fish, I have learned to strip bark off a cedar tree, make a headpiece, identify a stripped tree and give you an estimate of when it was stripped. I probably saw hundreds of culturally modified trees in the early days working in the valley and did not see them because of my lack of traditional knowledge.

I used to wonder, but now know why our Native origin stories always talked about throwing the fish carcasses back into the river or the fish may not come back. Our Elders may not have known the food cycle of salmon but they saw that the dead salmon served a purpose. The stories made us feed our river and ensured that our river would always replenish itself with salmon. To this day, we still throw the carcasses back into the river and ocean if we clean a fish near by.

I now know who our five 'Na'mimas (those of one kind) are; and what each of their names mean. I can tell origin stories to my grandchildren now. I may not say the words right in Kwak'wala but I can at least tell the story, the story that has been passed on from generation to generation. I cannot speak the language but I am getting very close to being able to read it. I can switch from the anthropologist Franz Boas's writing to the U'mista orthography in my head.

This is my own way of learning culture because I still refuse to dance in the Big House. It is not because I cannot dance; I refuse because I feel that I am not as good as the ones who do know how. I was laughed at once for my Big House dancing and still hold that fear. I did dance once but the one and only time I did was because of my respect for our Granny Axu. She was one person you did not say 'no' to. She was one of the last people who taught me Native pride. Because I respected her so much, I could not refuse to dance. I know that there are others who still mock rookie dancers. I remember being laughed at about my dancing. It hurt even more when the laughter occurred at a social occasion where it really embarrassed me.

A strong Native upbringing teaches respect for family and community, and especially Elders. So I have decided I will be an asset in other ways to the 'Namgis Band and its people by researching, recording, documenting and making sure that all the information is there for future generations in the Band archives. Sometimes I feel that our Native people are our own worst enemies. I hope by reading this, the mockers will see the damage done by such acts. Isn't it bad enough we have to fight the government and racial prejudice without having to further compound the problem with our own naivety and a need to feel superior to our own Native people.

I no longer feel that I am a ward of the state that the Federal Government should look after. I want equal rights, as any other Canadian citizen has. I am tired of people saying that Natives get handouts. People should take the time to read about what has happened to Natives in Canada throughout time. The past affects who we are as people today.

Because of Lou, who told me to apply for the job I now have, I now know why I have always been attracted to the valley. I have roots there that go so far back I will not attempt to put a date to it. This is what anthropologists and archaeologists do, but I know in my heart my roots have been here forever.

Diane Jacobson

Many 'Namgis people have never been in the Nimpkish valley nor trekked over the routes that our Elders travelled over for many centuries. We have been living in Alert Bay since the late 1800s. Some 'Namgis people still hunt in the valley, and they are some of the only ones who have seen its beauty. Our people were relocated to a small island and that inhibits our chance of getting to the valley.

I have been one of the lucky ones to have fallen into the same rivers that the Elders paddled and walked over, and walking in the same bushes that they hiked for many a mile. I am and always will be part of the Nimpkish Valley. I would like to be cremated and have my ashes spread from the Woss-Nimpkish River junction to the mouth of the Nimpkish River.

The mouth of the Nimpkish River is where the village of Xwalkw originally stood proudly, and where my ancestors proudly welcomed Captain George Vancouver into their Big Houses in July, 1792. One of the chiefs who met Captain Vancouver was named Kodi, and that name is still held by one of my cousins.

I have gone back to Woss Lake numerous times to camp. I have gone and cleansed myself in the glacier stream at the head because I now know that our Elders did this before they crossed the Grease Trail to Tahsis.

The name of Woss came about because it originates from Wa'as, a 'Namgis word that means "place of river." If this word was spelled Wa's it then means "river on ground." I have learned that a subtle change in the word can totally change the meaning.

Our band has built hunting and camping cabins in our valley for member use. We have one on Wa'as Lake and another at Vernon Lake for all band members' use.

Local painters and carvers are putting in new pictographs, telling of our origin stories on the Woss and Nimpkish Lake rock bluffs. One new pictograph depicts a salmon swimming upstream because we are the Salmon people. These pictographs are replacing the old ones that are now fading from weather and lichen overgrowth.

There is a standing, living, carved cedar tree depicting a Thunderbird at the beginning of the Grease Trail. There is also another Wolf design further up the trail that shows our marital and family ties to our West Coast relatives. Band members are once again using the Grease Trail from Woss to Tahsis to attend functions at Friendly Cove.

The kids from our Native school go and camp in the valley at the end of the school year so they can learn about our rich traditions. Cedar bark weaving is taught to the young children, and they are taught about Indian medicinal plants found in the valley while camping. Our band has gone so far as to take the treaty parties from the Federal, the Provincial and 'Namgis offices to camp at the head of Woss to hash out our treaty issues.

Chapter Thirty-Seven
Łaxwe'gila - Canoe Journey

In 2002, our people hosted a five-day Canoe Journey called Łaxwe'gila, which means "Gaining Strength." We welcomed the guests and canoes to Woss Lake the first week of August. Three days were spent at Woss Lake and the final two were in Alert Bay.

Organizers managed to find over $100,000 through grant applications and fund-raising events to host the journey. The Treaty Natural Resource Department, which I am part of, participated with camp cleanup, tent set-up, firewood collection, food preparation, canoe transportation over the logging roads from the West Coast area and many other duties that were unforeseen.

Twenty-one First Nations arrived at Woss Lake for the three days of camping, and the population of the campground numbered over eight hundred participants by day three. We gave workshops on cedar weaving, origin stories, medicinal plants, carving and made canoe journeys to see the pictographs on the lake. Many who brought their own kayaks paddled the length of the lake along with the larger cedar canoes to Rugged Mountain and did a healing cleanse in the glacier stream.

There was a traditional canoe race and the Whonnock canoe placed first. Bert knew we were going to win. He helped build the canoe.

"It was a foregone conclusion, guys." He said this over and over to anyone that would listen with that usual grin on his face. It was one of the highlights of the three-day event. I was proud that it was a 'Namgis canoe that had won.

Food was supplied by 'Namgis facilitators for the daily meals and prepared by 'Namgis band members and anyone else who wished to help. During the evenings, Lahal (gambling bone game) was played in different campsites throughout the night. I cannot even describe the feeling I felt as I walked about listening to the drums beating and songs sung in Kwak'wala, Coast Salish, Haida, Nuu-chah-nulth and many more.

The winning team would be shouting and hooting with excitement as they won more and more bones from their opponents. Laughter was heard throughout the night as the games became more about taunting your opposition, with the singing and drumming escalating by the hour.

Faces were only lit by starlight and the fire, which gave me a feeling of being transported back in time to when our Elders played these same games in this same spot many years ago.

I was getting tired and went to my tent but I could still hear the drumming echoing back to the campsite from the surrounding mountains. I lay there listening to the steady beat of the drums and it lulled me to sleep in minutes.

On day three, we started to pack up the tents and moved to the Gwa'ni Hatchery so that the canoes could head across from the mouth of the river to Alert Bay for the final two days.

More canoes had arrived and joined us at the river for the paddle across to Alert Bay. Unfortunately, a band member had passed away and the Whonnock family was unable to paddle across because she was an aunt to Bert. This news was brought to us just as we were ready to head across Cormorant Channel to Alert Bay.

It was a downer to everyone but I knew that the next two days in our village would bring spirits back up and it would help the Whonnock family deal with their loss.

I was in the canoe representing the Mamalilikala, or Village Island people, where my mother's family came from. We came out of the river and many of the people in the canoes were singing the paddle songs that they had rights to. Our song that my Cousin Ernest was singing made us paddle in unison and made the journey seem less than arduous.

Within forty-five minutes, we were outside of the Bay. Native protocol had us tie up together to be traditionally welcomed by our chiefs and allowed to come ashore. Each canoe went in when called by our 'Namgis Chief.

It was quite a sight to sit out on the water holding on to other canoes and seeing nothing but canoes with Native people wearing their traditional regalia. The sun was making the ocean sparkle and the mountains behind us were shiny blue, with a light dusting of snow on their peaks.

As I looked at the shore and saw our people standing in front of the Big House by the U'mista Cultural Centre, tears came to my eyes. I was especially happy and proud of my Native heritage on this day. All one could see were our Band members standing on the beach in button blankets, cedar bark hats and cedar headpieces.

Canoes backed on to the beach with paddles in the air once they were welcomed. This was the traditional way of showing that you came in peace, not warfare.

Everyone then walked to the traditional Big House near the soccer field. I was amazed to a see tent city on our soccer field. The support groups that set up came earlier on the ferry and there was not an inch to spare on the field.

Dinner was served to all the guests and traditional dances and speeches continued over the next two days. By this time, our little island had over two thousand guests who were either canoe paddlers, support crews or 'Namgis band members who had travelled home for this momentous occasion.

I was glad that I was able to bring people to different areas of our territory to show them the spawning areas for salmon, tell origin stories, and participate in the various workshops. Everything I had learned from the hatchery crew enabled me to talk about fish and the valley. My knowledge from my present-day job let me tell origin stories. It was an uplifting feeling to my soul that I still cannot put into words to this day.

Chapter Thirty-Eight
Conclusion

In June of 2006, Bert Svanvik, my friend, mentor and family member went to see our ancestors at the young age of forty-six. I could not believe it when this happened because I had believed our age group was invincible. Bert was no longer just my younger brother Joe's friend, but had become a true leader in my eyes. Bert loved the valley more than I did and it was very hard to accept that he was gone from our lives.

My job as the treaty researcher gave me the opportunity to share information with Bert about the valley over the years. We both enjoyed talking about different things that I had come across. We both learned that Vernon Lake was called Tłagwạni'gwis or "red-coloured beach," Klaklakama Lakes were named after one of our 'Namgis men, Anutz Lake was actually Hi'lutso which means "double one inside" or "one lake in another."

We found out together that our Nimpkish River is divided into three sections by our Elders. The lower section is called Gwa'ni or "downstream side," the middle section from the top of the lake to the Woss/Nimpkish River junction is called Tła'anis, meaning "rough terrain," as the crew found out earlier, and the upriver side is known as 'Nạldzi or "upriver side from the junctions to the height of land."

There were many other Native words and place-names we discussed together, and we encouraged each other to start using them whenever we talked about the valley. I shared these words and place names with our students from Alert Bay on their field trips in the valley because it is what Bert and I had discussed doing numerous times.

Our staff recently took the kindergarten, and grades one, two and three classes to Nimpkish Lake. We took them down the lake to see the pictographs, and William told us what he thought the origin story was that was pictured. After the boat ride, we took them to Pink Creek outlet and had a picnic. I told them that there was a village site on Pink Creek called K'awis, that translates to "pond on creek." We shared that Pink Creek is a well-known coho spawning area. I told them that our Elders travelled from Alert Bay in 1896 by canoe and arrived, in six hours, at the spot where we were eating.

In my mind, I visualized Bert saying, "Atta girl, Honey. Make sure the kids know that we have fished, hunted, trapped and lived in the valley for years. Let them know they should keep coming into the valley and enjoy it as we did."

I had to go to Victoria for the first time in late August of 2006 to do some research at the archives. I left to come back home at four in the morning and reached the Schoen Lake and Davie River turnoff just as the sun was rising over the mountains. My thoughts went to the time when Bert and Lawrence (Spider) swam the Davie River above Klaklakama Lake in late October to look for coho for our salmon broodstock.

I was the driver for the two men. These thoughts were in my head in a matter of minutes, and I started to cry because I had not let myself grieve properly for Bert. Each time I passed a familiar area, I cried again thinking about different things I had done and experienced with Bert. But they were big, happy tears and memories as I passed the turnoffs to the Davie River power lines where we had caught coho.

This section of the river was located near a very steep embankment. I pictured Bert carrying one section of a seine net up the slippery embankment, wearing his dry suit, sweat pouring down his forehead. He made it look easy as the rest of us struggled with the same hill, carrying bundles of rope and other parts of the net. We had walked and grabbed onto branches while Bert had run up the hill with a bundle that easily weighed over seventy pounds, never reaching out to the branches for support!

Croman Lake appeared and I remembered the laughter and fun we had as we set up our nets to fish in this spot on the Davie River. A crewmember named Gerald had some leeches attached to his dry suit as we walked down from Croman, and the fear in his face when he saw the leeches. Bert laughed out loud telling him to "man up, guy," smiling the whole time.

When I passed Nimpkish Lake, I thought of when Phil had told me about the time a bear was creating havoc at the Willow Creek hatchery by attacking the garbage cans, the fish and harassing the workers. The crew was starting to get worried about their safety.

Phil had gone to sleep late one night on the living room couch and awoke to a loud gunshot blast. Bert had seen the bear on the front porch. He had inched his way to the door with his loaded gun and slowly opened the front door. As he let loose with his bullet, Phil had jumped almost three feet in the air from the couch in fright. He told me that he did not know what the noise was but it scared the living daylights out of him. The bear was no longer a bother at the Willow Creek Hatchery.

As I passed the hatchery site by the Nimpkish River Bridge, I laughed out loud as I recalled the time that Bert was training some new guys. They were all sitting on chairs, stripping the female fish into buckets, and Bert said to one of them, "Head back further, further." Bert looked up, puzzled, wondering why the new guy could not get a good belly cut, then burst out laughing and had to put his bucket and stripping knife down to wipe his eyes.

Johnny was pushing his own head back further and further. Bert had meant for Johnny to pull the fish head back, which would allow him a better cut and access to the fish eggs in the belly. Every time any of us caught Johnny's eye after that, we all tilted our heads back. This only made Bert break out in laughter again.

Woss Lake, CB 9/11, Kilpala turnoff and many other spots, along with the hatchery site itself, passed by as I drove, which all brought so many good memories back to me.

I was able to laugh, cry, and reminisce about the good and bad aspects of my job in the valley but still come to terms with all the various feelings I had during the forty-five minutes of my North Island Highway drive through 'Namgis territory.

It felt like Bert was with me as I had these flashbacks of twenty years of working in the Nimpkish Valley with him and many others, such as my teachers, employers, Elders and co-workers. With these people, I had learned to love myself, to enjoy life to the fullest and never stop attempting to learn, even though it could be hard work at times, both mentally and physically. They gave me the strength to look at, learn from and accept Bert's death.